PAINTING AND DRAWING FROM PHOTOGRAPHS

BY URSULA KAISER
FOREWORD BY WENDON BLAKE

WATSON-GUPTILL PUBLICATIONS/NEW YORK

First published 1984 in the United States
and Canada by Watson-Guptill Publications,
a division of Billboard Publications, Inc.,
1515 Broadway, New York, N.Y. 10036

© 1982 by Otto Maier, Publisher, Ravensburg. Illustrations
and photographs by the author, except pages 6 and 7:
Pablo Picasso, courtesy of SPADEM, Paris/Bild Kunst, Bonn '81;
pages 29 and 67: Remo Copparini, courtesy of the artist;
page 64, Estes/McLean, courtesy of the city of Aachen, Neue
Galerie—Ludwig Collection; page 65, Ralph Goings, courtesy
of the city of Aachen, Neue Galerie—Ludwig Collection; page
65, John Rummelhoff, courtesy of Publications Filipacchi,
Paris.

Library of Congress Cataloging in Publication Data
Kaiser, Ursula.
 Painting and drawing from photographs.
 (The Artist's painting library)
 1. Painting from photographs—Technique. 2. Drawing
from photographs—Technique. I. Title. II. Series:
Blake, Wendon. Artist's painting library.
ND1505.K35 1984 750'.28 84-3507
ISBN 0-8230-3634-0

Manufactured in Hong Kong.

1 2 3 4 5 6 7 8 9/88 87 86 85 84

CONTENTS

Painting and Drawing from Photographs. We all know that the camera has become an enormously useful tool for people who paint and draw. The camera is a rapid and efficient "sketching" medium for the artist who wants to gather material quickly on location, and then work from color slides or black-and-white prints in the leisure of the studio. But most professional artists and teachers would agree that working from photographs isn't merely *copying* the image that's recorded on the film. The purpose of the photograph is to give you an *idea* for a painting or a drawing, and to provide raw material that you can re-shape and interpret in some personal way.

Ursula Kaiser's sparkling book explores the many ways in which you can use photographs as points-of-departure for paintings and drawings that are truly creative and truly your own.

Interpreting Black-and-White Photos. The heart of the book is a series of two dozen projects that will inspire your creativity and suggest many more ways of using photographs as the basis for paintings and drawings. The author presents three simple black-and-white projects to get you started. She shows you how to make a simple drawing from a black-and-white photograph clipped from a magazine; how a black-and-white photo of some natural detail, like the pattern in a rock, can stimulate half-a-dozen different designs in paint and collage; and how to look freshly at ordinary tourist snapshots and discover an amazing variety of painting possibilities: handsomely designed landscapes, figure studies, architectural views, and outdoor "still lifes."

Simple Projects in Color. The first three color projects follow the same logic as the introductory projects in black-and-white. You see how an unpromising snapshot of green leaves can be transformed into a bold, realistic painting with a strongly designed pattern; how a snapshot of food from a day's shopping expedition can be transformed into a brightly colored, sharp-focus still life painting; and how a vacation snapshot of skiers can be simplified and redesigned to dramatize shapes, colors, and outdoor light.

Experimental Projects. Now you're ready for some projects that are less conventional, more free-wheeling. Dipping into some more of those tourist snapshots that so many of us bring home from our trips, the author shows us eight different experiments. The first project starts out with one of those tourist snapshots that make us wonder, "Why did I photograph *that*—and what is it anyway?" But this flawed picture becomes the basis of a powerful, semi-abstract figure group with dramatically colored shapes. An oddly composed snapshot of a hotel swimming pool and garden becomes a sunny outdoor painting. A slide of the wiggly reflections in a Venetian canal becomes the basis of a semi-abstract painting that really communicates the essence of sunlight on water. Two snapshots of architectural details produce handsomely designed paintings that combine realism and abstraction. You'll discover how to find a creative use for a failed snapshot that contains a double image or a blur; the finished drawing in colored pencil actually exploits the camera's mistake. A memorable demonstration shows the step-by-step transformation of a street scene into a line drawing, then into a flat pattern of colored shapes, and finally into a realistic (but simplified) painting. The final color demonstration shows how a color slide takes on a totally new life as a mosaic of colored shapes.

Experiments in Black-and-White. The book concludes with a series of drawing and painting experiments based on black-and-white photos. To cite just a few examples, you see the complex detail of a photo of flowers simplified into a powerful drawing of a single blossom; two different ways of making a drawing from a photo of a sculptured head; two different ways of interpreting a photo of industrial machinery; how photographs become the basis of portrait and still life drawings; a step-by-step demonstration of the stages in making a pencil drawing of the stark pattern of trees photographed in winter; how a blurred photograph of a bicycle race, clipped from a magazine, becomes the foundation of a pencil drawing that's even more magical and mysterious than the photo.

Open Your Eyes! These two dozen projects will open your eyes to the vast number of creative ideas that you can find with your camera, discover in the pages of newspapers and magazines, or dig out of the drawer where you keep all those snapshots that were never intended to become the basis of paintings or drawings. The possibilities are as unlimited as your imagination.

WENDON BLAKE

We see the visible world that surrounds us as space, filled with objects, forms, colors, light, and shadow. In each moment we experience so many sensations and impressions (smells, sounds, feelings of touch and temperature, moods and thoughts) that it is impossible to perceive them all at the same time with equal intensity and consciousness. Photographs are pictorial sections of this world projected onto a flat surface. They are made with the help of an optical apparatus, the camera. But the camera can grasp and reproduce only what we see—not what we smell, feel, think. For all its technical differences, the camera corresponds, in principle, to our own optical apparatus, the human eye. A photograph, therefore, is in many respects similar to the image that falls on the retina of our eye—so similar, in fact, that many consider a photograph to be the most realistic way to present the visible world.

Perceiving Space and Volume. We are able to see spatially, that is, to perceive the volume and texture of objects and their distance from us, because we see with two eyes. The eyes view an object from two different points: the field of vision of each eye overlaps, but the right eye sees the object somewhat more from the right, the left eye somewhat more from the left side. The impression of physical volume results from this. This effect is naturally stronger for close objects than for those further away; by this difference in appearance we can, with experience, evaluate the distance between us and the object viewed.

Most cameras record the object through a single lens. The photographic image is therefore flatter than the naturally perceived image.

Optical Distortions and Foreshortenings. Besides flattening the image, a photograph will contain optical distortions and foreshortenings which would be quite clear in everyday life. This is because our brains have a memory bank of images to help us interpret what we see each moment. In fact, our visual perceptions are strongly influenced by our previous visual experiences. When we look at a street we do not see the optical distortions and foreshortenings, for example, the receding lines of the houses, nearly as strongly as when we look at a photograph of the same street taken from the same point. The photograph dramatically accentuates optical distortions and foreshortenings; the actual spatial and size relationships of the objects in a photograph can be evaluated only with difficulty.

The Perception of Light. Our human eye is more sensitive and adaptable than the camera: it is able to compensate for strong changes and differences in light by enlarging or contracting the pupil. In this way we can recognize both well and poorly lighted objects, even if they are standing immediately next to one another.

The "eye" of the camera, however, cannot make the continuous rapid adjustments of the pupil, and will focus on either the brightest or the darkest parts of the composition. The entire scene is taken in with one snap of the shutter: the over and under-illuminated parts equally. However, the photographer can select a shutter opening (called an f-stop) which will balance the strong differences of lighting in the scene. This f-stop corresponds neither to the darkest nor brightest parts of the scene, but rather to a value between them. This is the most frequently practiced method of exposure and avoids the danger that individual parts of the compositions will be lost in shadow. However, one mustn't forget that a photograph of this type is always a falsification of the real light relationships and is therefore not truly *realistic*.

Image Sharpness and Depth of Field. The human eye and the camera lens also differ in their ability to see and record image sharpness at varying distances. The lens of the healthy human eye has the ability to focus sharply and continuously in fractions of a second. This ability is called accommodation or adaptability. For example, when observing a landscape in which some objects are in the foreground and others in the background, the eye is constantly refocusing as it darts about the scene. Natural vision, then, consists of a series of sharp images with changing depths of field and is experienced (for people with normal vision) as a continuous, uniformly sharp, visual image. In a photograph, however, only part of the landscape will appear in sharp focus because the shutter (pupil) of the camera opens only once. So, the photographer adjusts his camera before shooting (by selection of lens, f-stop, exposure time, and distance) and chooses which depth of his composition (foreground, middle, or background) will appear sharp. He can photograph the same scene so that the foreground, middleground or background lies within the depth of field. But each photograph can only reproduce a specific depth of field with absolute sharpness. The difference in sharpness can be minimized with shorter focal lengths and higher f-stops.

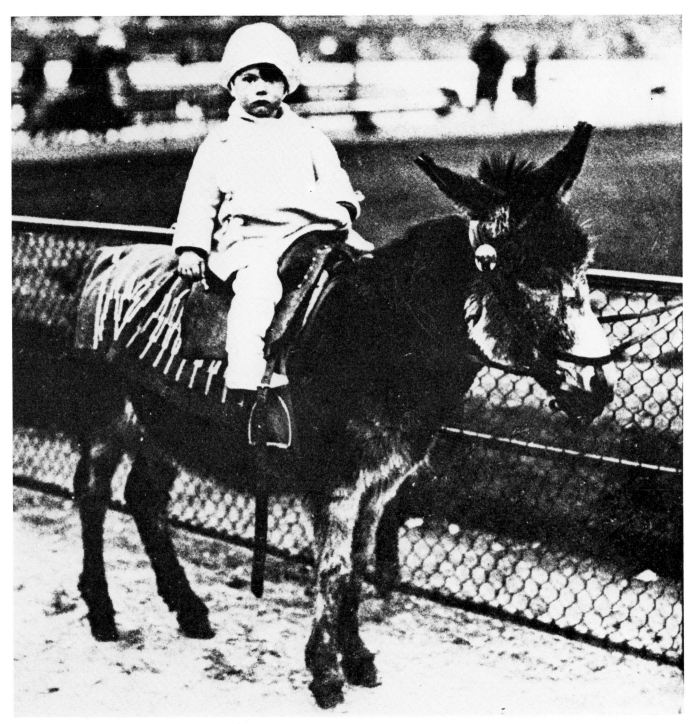

Static and Movement. We should consider another difference between a visually perceived image and a photograph: that which is perceived by the eye is fleeting; the photographic image is static. If we look at a moving object, people passing by, grass in the wind, or a passing car, the image on the retina changes in fractions of a second. Every eye movement, every turn of the head, every change of viewpoint or of illumination, changes the image that the eye perceives.

Image Boundary and Selection. A further essential difference between what we see—the retinal image—and the photograph lies in their boundaries. The photograph is firmly bounded (mostly rectangular or square, less frequently round or oval) and sectional—showing only a section of the scene the eyes saw. People and objects can be lifted and cut out of their environment, which, for a correct understanding of the situation, may be important. The boundaries of the retinal image, by contrast, are much less clear-cut; although sharpness may decline at the edges, even without turning our heads we still pick up many illuminating details out of the corners of our eyes.

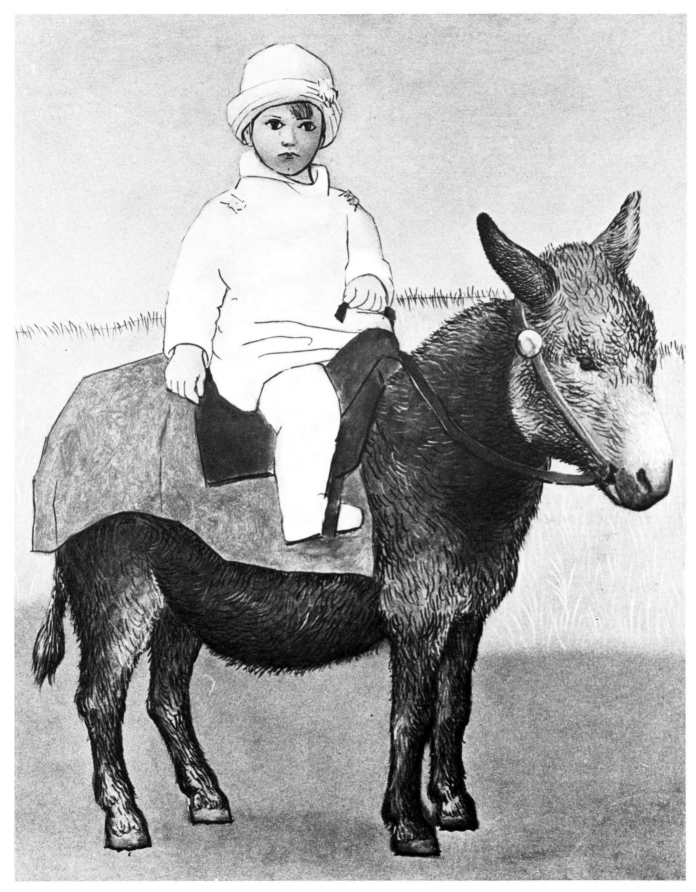

Left: Unknown photographer: Picasso's son Paul on a burro, 1923.
Above: Pablo Picasso: Paul, son of the artist, 1923.

The Perception of Color. No one would argue that black-and-white photography is an alteration of visual reality: it reduces the fullness of color nuances to light and dark values. But that color photography also renders colors differently from how the eye sees color, is not always realized by those who deal with photographs. Even in color photography, peculiarities of photographic illustration are true and colors are changed and flattened.

Of major importance is the fact, mentioned previously, that the eye perceives objects and their surroundings point by point, while all optical and chemical processes that belong to photographing and enlarging color photos (selection of lens, film and developing chemicals, f-stops, exposure time, distance, and different filters) always operate on the entire image surface at once. For example, in the darkroom in order to produce clear natural skin tones, a color filter is used which might dull or alter the color of the foliage in the background of the same picture.

A further factor essential in influencing photographic color, is the *temperature* of the light at which the photograph is taken. Both daylight as well as artificial light can be quite different. Daylight at sea, in the high mountains, or in shadow has a high proportion of blue rays, while in the setting sun the red rays predominate. Artificial light sources are equally different in temperature (normal light bulbs or neon lighting for example). While the human perceptual organ (eye and brain in unison) is concerned with equalizing color differences that depend on light temperature (we perceive a white house in the morning, noonday, evening, or moonlight as white), color film clearly recorded these differences which make filtering necessary.

Photography as Creative Technique. Photography is, therefore, in no way the ideal means for realistically portraying our surroundings. It is a picture world made by humans, an expression of human dreams, hopes and anxieties. A photograph is an aesthetic object, whose beauty depends as much on the individual perceptions and creative will of the photographer as on the technical perfection of the equipment and the chemical processes employed. We, therefore, understand photography today as an independent creative technique that neither delivers realistic likenesses nor can be equated with freely painted or drawn images.

The Role of Photography in Art. Despite this, photography has, since its invention, been used by many painters—more than is generally known—in many different ways for their artistic work. There are pictures and drawings which originated from photographs by Delacroix, Courbet, Manet, Degas, Cézanne, and Gauguin, to name but a few of the most famous painters of the 19th and early 20th centuries. These artists were fascinated by the new medium, which they hoped would help them to record reality more precisely. It was a group of contemporary painters who made us conscious of the independence of photography as a creative medium. These artists, to whom Estes and McLean belong (see p. 64), began using photographs as a basis for their pictures in the middle of the 1960s. They painted pictures from photographs or slides in greatly enlarged formats and as exactly as possible. Their aim was to avoid the characteristics typical of a free artistic technique, such as visible brush marks and thick paint. For them, the photograph was no longer an aid to producing a painting, but rather the image of the painting itself. Where a realistic artist attempts to portray an apple with all its particularities—its color, the shine of its skin, its three-dimensional roundness, even its scent— the Photorealists would reproduce the characteristics typical of the photograph itself: its sectionalness, its flatness, its limited depth of field, interesting optical distortions, the beautifully lighted colors harmonized by chemical processes. It is easy to see that the photograph, even when meticulously reproduced, is changed by the enormous enlargements ten, twenty times its original size. For example, in a photograph a color changes from red to blue within a single millimeter, but the painter has 20 or even 50 millimeters of space for this transition on his canvas. Because of the enlarged proportions he is forced to employ his entire imaginative power and sensibility to color, to create this color transition. The artist strives, of course, to reproduce the picture in its photographic particularities as exactly as possible, but the work of translation still permits him room for artistic interpretation. He can choose to make the colors more full or a bit bleached out, he can emphasize either the flatness or the illusion of space in the photograph, he can emphasize the depth of field zone, and so on. Such changes of accent become quite exaggerated on the enlarged canvas, allowing the characteristics typical of photography to become immensely clear.

To draw or paint from a photograph it is usually necessary to enlarge the photograph by some means. How exacting such an enlargement should be depends on the particular intention of the artist. For example, if the artist wishes to reproduce the entire photograph in his painting, a simple enlargement will suffice. If, on the other hand, only a portion of the photograph is desired, a more exact enlargement technique is necessary. The Photorealist will take care that his enlargement is an exact replica of his original photo (see pages 52 to 55).

There are different enlarging techniques. The artist should select the method best suited to his creative intention.

1. Screen Techniques. First, the exact section of the photograph is selected. Then, how narrow the square grid must be in order to provide sufficient reference points for the enlargement is considered. A very finely detailed picture naturally requires a thicker grid consisting of many small squares. There are different ways of imposing the grid on the photograph.

Method 1: Draw the lines directly onto the photograph with either a medium-soft pencil (lightly wiped), or a very fine drawing pen and India ink. The disadvantage of this method is that fine details can be covered over or made unclear.

Method 2: The grid is scratched onto a stiff, colorless, transparent plastic sheet, laid on top of the photo, and so bound on one side with transparent tape, that the grid sheet can easily be lifted and set back down without being displaced (see illustration). This method has the advantage of allowing the photograph to be viewed with or without the grid as required.

The canvas is now divided into as many squares as the plastic sheet. If the grid over the photograph has dimensions of 12 squares wide by 8 squares high, the canvas must also be divided into 12 by 8 squares. Logically, the squares must be larger. Now the artist can copy square for square. It is best to begin at the top left. Everything to be seen on one small square of the photograph is transferred, enlarged, onto the corresponding square of the painting or drawing surface. Tip: pay attention to the relationship of a point or line to the sidelines of the surrounding square. For example, notice where a line cuts the square line; in the middle? at point 1:3? 1:5? (On pages 58 and 59 you can follow the procedure exactly.) This method can be used for any type of enlargement (e.g., for wall paintings).

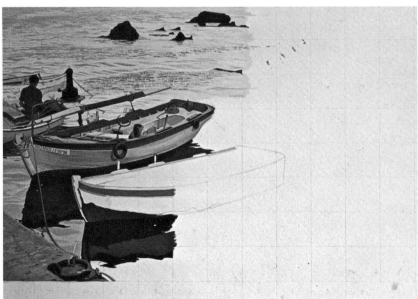

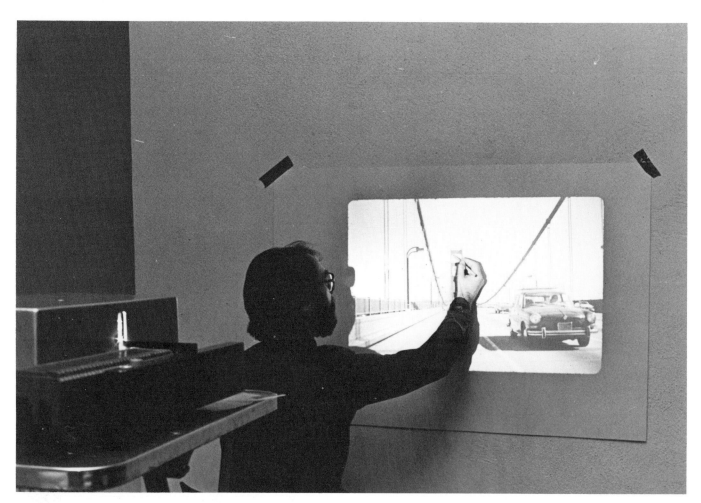

2. Projection Technique. Slides are best suited for this enlarging technique. Project the photographic image directly upon the drawing surface (drawing paper, canvas) in a semi or three-quarter darkened room. The artist must stand before the drawing surface in such a way that the beam of light is not interrupted and draw or paint the projected image. The projection beam can be interrupted by the artist's body as a control for what has been actually rendered on the drawing surface. Enough can be seen in semidarkness so that the light does not constantly have to be turned on and off.

The projection method can be used to sketch in only the most important reference points of a picture, to make a complete contour drawing, or to paint the entire picture with all its forms and colors.

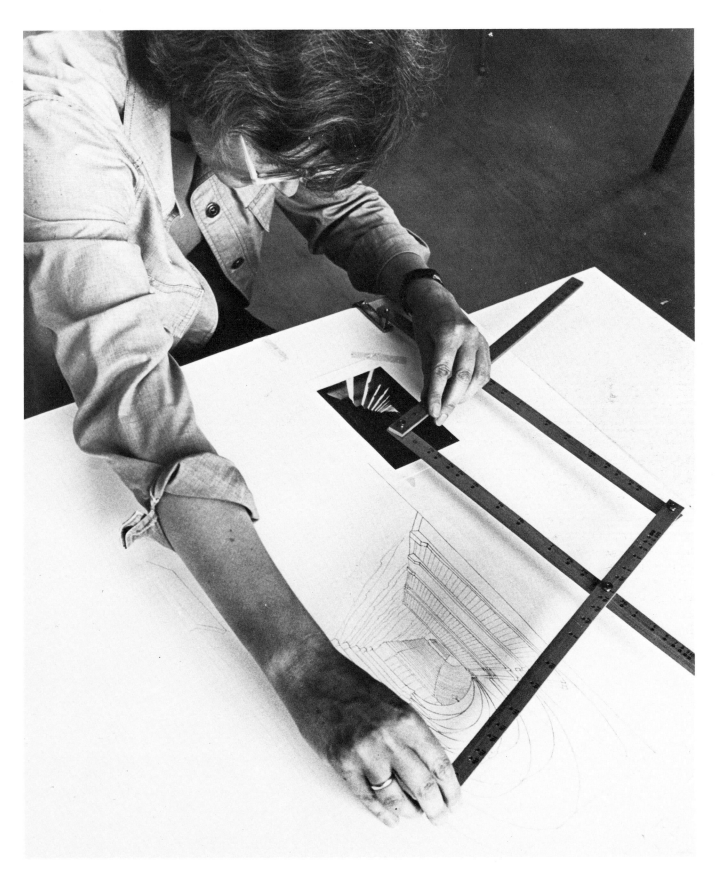

3. Pantograph Technique. The pantograph is a simple drawing tool, used for copying, enlarging, or reducing original copies. It consists of four rods connected according to the instructions. The left hand measures the original photograph, while the pre-measured enlargement is drawn by the rod system attached to the end of the rod worked by the right hand. This method requires some dexterity (both hands) and is especially suitable for simple compositions.

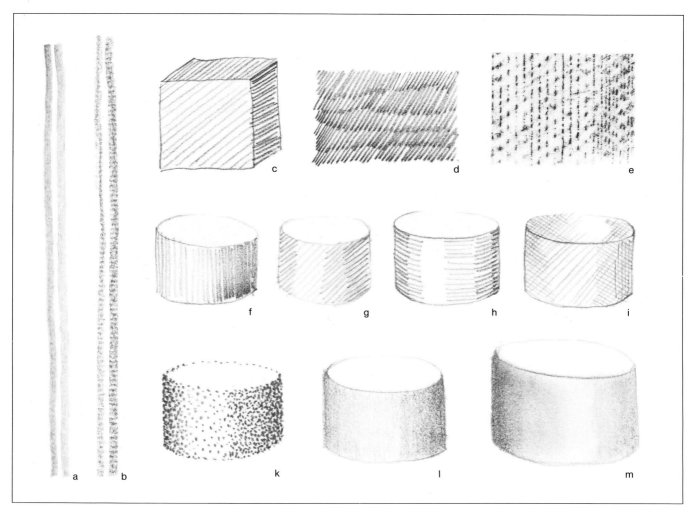

Pencils are sticks of graphite lead bound in wood with the addition of finely ground shading, binding, and hardening ingredients. There are about twenty different grades of hardness: the soft B variety (B to 8B), the medium variety (HB and F), and the hard variety (H to 10H). There are also graphite leads (in thickness from 0.3 to 3.2 mm) which are placed in lead holders. The point can be adjusted with pressure, the lead sharpened on fine sandpaper. The drawing surface for work in pencil is usually paper: white, toned and colored varieties, lightly or heavily glued, glossy, somewhat coarse, or structured (e.g., simulated handmade). The appearance of the pencil line will change according to the texture of the paper (see sketches a and b).

Erasers for hard pencil lines: rubber erasers, soft erasers. For soft lines: soft erasers. For very soft lines: gum erasers.

Fixing: All drawings, especially soft pencil drawings, must be fixed using a commercial fixative in spray cans or bottles. Spray the fixative evenly from a distance of 50 cm using a quick circular motion. Do not soak the paper. Use a small amount of fixative and repeat the process after drying until the lines are no longer smudgeable.

a) Pencil lines on smooth paper.

b) Pencil lines on simulated handmade paper (Ingres paper).

c) Even hatching: Number of lines, thickness, and space between lines determines the darkness of the hatched surfaces.

d) Larger surfaces put together with rows of hatchings: a lively, compact, vibrating surface.

e) Frottage: To achieve interesting textures, the paper is laid over a surface with a raised pattern. When the paper is rubbed with a dull or flatly held lead, the texture of the surface underneath comes through.

f) Molded hatching: light-dark variations achieved through different thickness, breadth, and darkness of the strokes.

g) Light-dark variations made with several parallel bands of hatching.

h) Form strokes: the hatching follows the plastic surface of the object.

i) Crosshatching: light-dark variations made with hatchings in various directions.

k) Point technique: light-dark variations made by altering the density of dots or points.

l) Gray applied flatly to avoid individual pencil strokes. The dull lead is drawn back and forth or rotated on the paper without interruption.

m) Softly applied pencil strokes smudged with the fingertip.

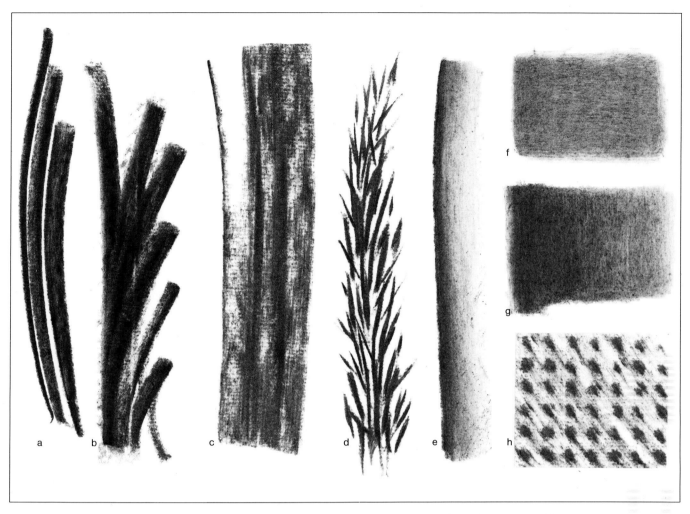

Drawing Charcoal is produced by slow carbonization of wood in a vacuum. There are three varieties: round sticks (with diameters of 3 to 14 mm), angular pieces (made by splitting thin strips), and charcoal bound in wood like a pencil. Charcoal comes in different hardnesses, mostly semi-soft and soft. The round sticks are softer than the angular pieces. The round sticks and angular pieces may be sharpened on coarse emery paper as needed. Drawing surface: paper which is not overly smooth (machine-made, handmade, packing paper, and newsprint).

Erasers: soft erasers, gum erasers.

Fixing: charcoal drawings must be fixed with special care (see under "Pencils").

a and b) Quick and rhythmically "written" lines and figures. There is a feeling of movement and a calligraphic quality to these bold, rapid lines; one can feel the movement of the artist's hand.

c) Gray surfaces applied with the broad side of a short piece of charcoal.

d) Structure drawn with the sharp edge of a charcoal piece.

e) A strong, broad stroke of charcoal rubbed on one side with a fingertip.

f) Gray broadly applied, rubbed to a consistent surface.

g) Gray broadly applied, rubbed to form a gradation of light to dark.

h) Frottage: the paper is laid over a relief surface and rubbed with the broad side of a piece of charcoal.

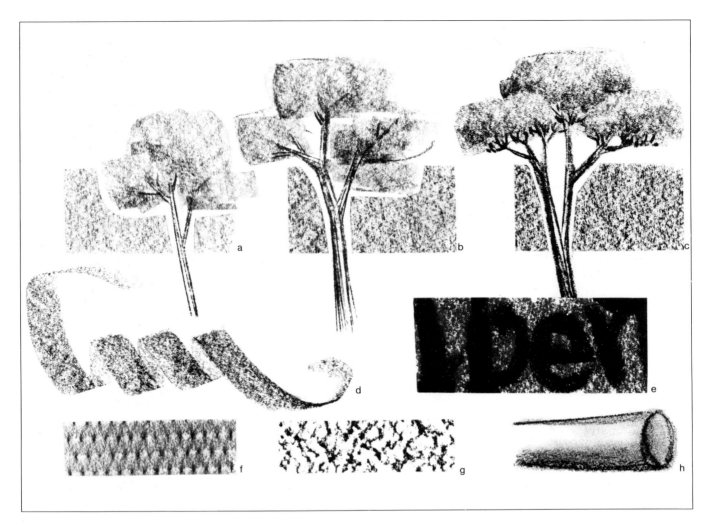

Drawing Chalk is a collective term for white, gray, or black chalk with or without wooden jackets, in rounded or edged form.

Black chalk: black colored powder (e.g., soot) bound with a little binder. Three grades of hardness: hard, medium, soft.

Edged stick (without wooden jacket): for broad-sided and angular work. Sticks with wooden jackets are used like pencils, but have a blacker and more powdery line. Black chalk drawings must be fixed.

Stone chalk or gray chalk: shaded pigments, weakly bound, in edged and round form. Up to twelve different shades of gray (warm and cold degrees of tone). Stone chalk drawings must be fixed.

White chalk (not blackboard chalk): offered in varying degrees of hardness in edged and wood jacketed formats.

Red chalk: ground iron oxide earth tones, weakly bound. Up to six reddish shades of brown, edged and wood jackets.

Colored chalk (the greatest differences are found with colored chalks): Conté chalks similar to pastels (though somewhat more solid), edged and wood jacketed; oil-pastel chalks (pigments bound with an oil bearing binding agent); thick, wooden-jacketed paint sticks that can be used as paint chalk or combined with water. Smooth paper should not be used for chalk drawings as the colored powder has difficulty adhering to it.

Erasers: soft eraser and gum eraser.

a) Broadly applied shading using edged chalk. The crown of the tree was sketched in the same manner. The trunk and branches, were drawn with the sharp edge of the stick for contrast.

b) As above with an edged stick of medium hardness.

c) As above with a soft edged stick.

d) This swirl was broadly "written" with a short piece of soft chalk. The changing shades of gray are particularly noticeable. These arise through variations in pressure applied while drawing.

e) A gray surface was broadly applied to a piece of rough paper. The dark areas were then drawn with the rounded point of the stick.

f) Frottage: the paper was laid on a relief surface and rubbed with the broad side of the chalk.

g) This surface was applied with the broad side of an edged stick on a highly textured paper (watercolor paper).

h) Rubbing technique: strongly drawn contour lines rubbed with the fingertip.

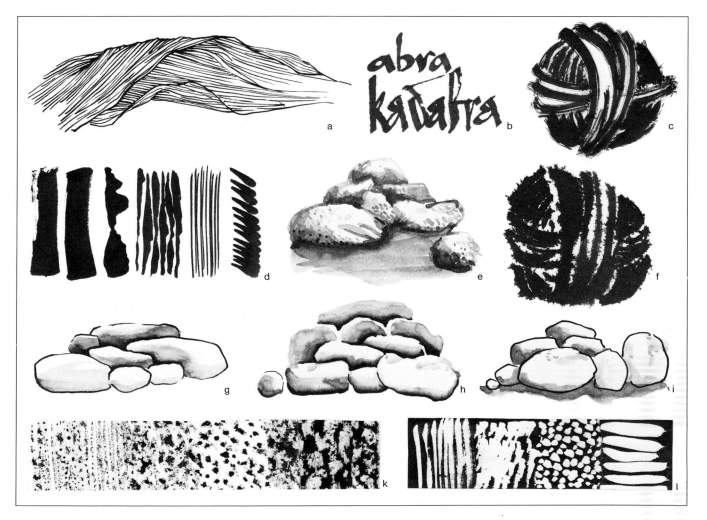

India Ink Drawing and Painting. Inks are pigments dispersed in liquids. They are available in several colors and shades. Most are transparent hues, but black and white are opaque. The India inks can be thinned with water, but once dry they are impervious to rubbing, water, and erasure. There are special inks for writing (particularly free flowing) and for drawing on synthetic materials (in soluble and nonsoluble form). Chinese ink is an ink in solid form. It is sold in cubes or sticks and must be wet with a little water and rubbed on a rubbing stone to produce ink. Inks are applied primarily with pens (tube, quill, steel pen, fountain pen) or with a brush (hair or bristle).

Drawing and painting surfaces: smooth paper for sharp pens; machine or handmade paper for brushes, tube, or quill pens. Erasing dried ink is barely possible, but can be done with care using a mat knife and a hard rubber eraser. The roughened paper must finally be smoothed.

a) Linear drawing with steel pen and ink. Drawing the individual fibers creates the illusion that the paper is turning.

b) Written with the tube pen. The waxing and waning of the lines results from the broadly cut point of the pen.

c) Drybrush technique: drawing with little ink on bristle brush (excess ink is rubbed off on a separate paper). The ink strokes do not flow together completely. Single brush hairs leave behind fine traces which follow the rhythms of the broader lines.

d) Structures drawn with ink and a soft hair brush.

e) Watercolor-like drawing done with thinned ink and a fine hairbrush on dry paper.

f) Wet on wet: the "ball of wool" is drawn with a hair brush and ink on moistened paper. The ink flows in fine veining.

g) Glazing: while the ink is still damp, a hair brush, wet with water, is drawn across the shaded areas of the drawing to suggest volume and shadows in the rocks.

h) Glazing: the wet ink line is made to run when a damp watercolor brush is drawn along one side. An effect similar to sketch g, but flatter because the line practically dissolves.

i) The shadings are drawn with thinned ink after the original line drawing has dried.

k) Random technique: ink structures on waxed paper. The partially waxed paper does not absorb the ink completely and is, therefore, an attractive foundation for brush drawings.

l) Brush technique: a drawing made with opaque white is painted over with ink. After drying, the surface is carefully brushed off with a bristle brush.

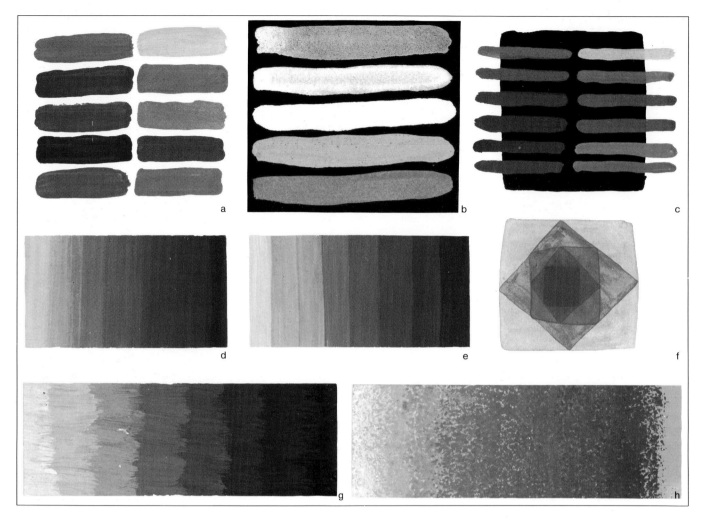

Opaque Watercolors, also known as designer colors or gouache, are nonfading covering paints. These opaque colors dry water soluble. Usually a bristle brush is preferred when using paint thickly, and a sable brush when diluting with water for glazed effects. Painting surfaces: strong drawing paper, watercolor paper, handmade paper, machine-made paper, Japanese paper, colored paper, illustration board. The paper does not have to be primed; to prevent wrinkles, the paper can be moistened and stretched like watercolor paper: soak paper first then tape to a board using paper tape.

a) Covering technique (left, unmixed colors; right, the same colors mixed with opaque white): When mixed with opaque white, colors become lighter and more subdued while increasing their covering quality.

b) The covering technique using bright colors on a dark background. The three upper color strokes show paint of varying thickness.

c) Covering techniques: unmixed shades and shades mixed with opaque white on a black background.

d) Blending technique: by carefully painting into one another, a seamless transition between the shades of color is achieved. This is difficult to do with opaque colors because the paint dries quickly.

e) Here the bands of color are not blended into one another. The color transition and the steps in the gradation from light to dark are clearly defined.

f) Glazing techniques are also possible with opaque colors. The color becomes more opaque with each layer.

g) A loose layering of different shades provides another possibility for creating color transitions. Through the rather coarse structure of the brushstrokes, the color tones become somewhat laced together.

h) Drybrush dabbing technique: thickened, pasty opaque color is dabbed on with a special dabbing brush or with a bluntly cut bristle brush. The surface can first be primed with a medium shade and then modulated by dabbing with a lighter or darker shade. When dabbing one must take care that the individual drops of color do not run into one another. Dabbing can also be combined with spraying (see "Watercolors") or carried out with tempera or acrylic colors.

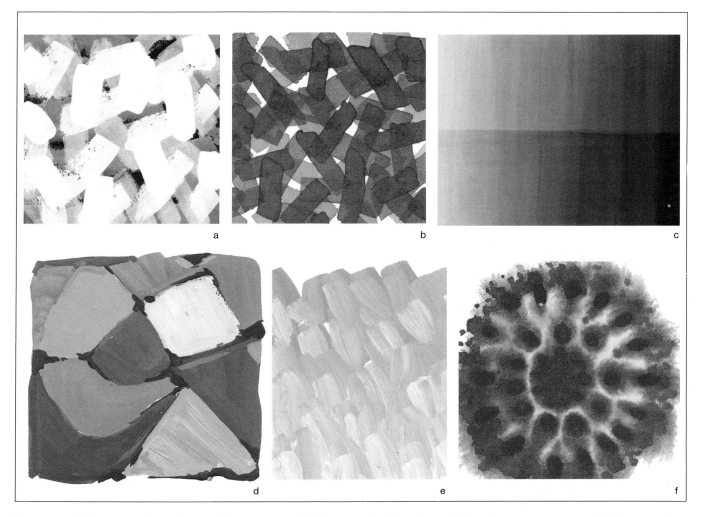

a b c

d e f

Tempera Paints consist of primarily opaque, highly durable pigments and an emulsified binding agent. Depending on the binding agent, tempera is differentiated as albumen, gum, glue, casein, or oil tempera. Gum, glue and casein tempera are thin; albumen and especially oil tempera are fat. Thin tempera paint dries dull; flowing color transitions are made only with difficulty. Fatter tempera paints dry shiny and are most suitable for thick application. Tempera paints can be applied with a hair or bristle brush; the fatter sort can even be applied with a painting knife.

Painting surfaces: For the thinner tempera, you can use paper, pasteboard, or cardboard, unprimed or lightly primed (with a thin coat of acrylic gesso). Porous cardboard, fabric, wood panels, and hard pulp boards must first be primed with a thin binder. Oil tempera requires the same priming as oil colors (see page 23).

Varnish: tempera painting distinguishes between unvarnished and varnished styles. Unvarnished tempera painting is done with thin colors, using glossy, opaque, but never pasty application. Varnished painting is done with fatter tempera colors, using glossy or cover coats and a final varnish, or several layers of intermediate varnishes. The varnish makes the colors more brilliant, saturated, gleaming (sketch c).

a) Covering ability of tempera colors of different thinness (here with casein tempera thinned with water).

b) The same, but dark on light. Tempera paint becomes more quickly opaque with each additional layer than does watercolor.

c) Flowing color transitions using thin tempera color are made only with difficulty. Unvarnished above, varnished below.

d) Relatively thick application of color. Loosely brushed color areas are painted over a darker prime coat.

e) Loose application of color not thoroughly mixed, using clearly visible, rhythmic brush strokes. The overall pattern and the seemingly haphazard tonal transitions create a lively surface. (For placing related colors or shades next to one another, see "Opaque Colors" sketches d and e.)

f) Wet-on-wet painting: for this only thin temperas are suitable, in this case casein tempera. The paint is applied to moistened paper. The color blossoms forth creating bizarre color patterns that stimulate the imagination. By practicing wet-on-wet painting, one learns to anticipate some forms and guide the chance occurrences that make this technique so exciting. This technique can also be employed with watercolor, ink, and extremely diluted opaque paints such as oil paint.

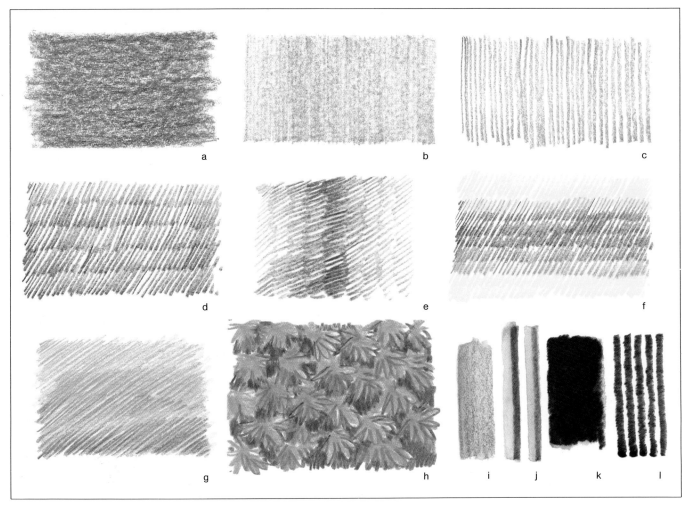

Color Pencils come in wood jackets with thin or thick leads (2 to 10 mm) of varying hardness (from 2H and 4H pencils to paint-like soft pencils) and in over 50 shades. Usually they are partially or completely soluble in water. They are suitable for creating both linear drawings, such as contour drawings, and more planar images. Pencil areas may be painted with a wet hairbrush (using water, watercolor or ink) and drawn over when dry or while still wet. This technique combines several methods of color application with one another.

a) Filling the surface with a bold back-and-forth motion of the pencil to create a dynamic, unstable effect.

b) Filling the surface with a very thick, controlled, application of vertical lines using a somewhat blunt point: a quiet, static, unmoving surface results.

c) A somewhat freer though still relatively controlled filling of the surface with hatching. Stroke thickness, breadth, and pressure during drawing determine the darkness of the surface.

d) Filling the surface with hatch rows drawn into one another. The result is a lively surface with strong spatial possibilities.

e) Molded hatching in variable light and dark rows of hatching. This application suggests plastic effects.

f) Optical color blending by drawing different colored hatch rows into one another. The color mixing is created, not so much through a blending of the color pigments, but through the eye of the beholder. Very fresh color effect.

g) Blending of color by placing different shades over one another. Here, yellow, green, blue, and brown are used and the effect is a combination of pigment and optical blending.

h) Rhythmic and colorfully structured surface by drawing over complimentary structures in green, blue, and brown. A colorful creation with expressive possibilities for deep spatiality.

i) A filled-in surface, similar to sketch b, has been smoothed over with a wet brush. The color of the pencil was only partially dissolved and some of the pebbley texture remains.

j) Pencil lines repainted with a wet brush along one side only.

k) and l) Application of colored pencil on moist paper creating dark, thick shades and textures.

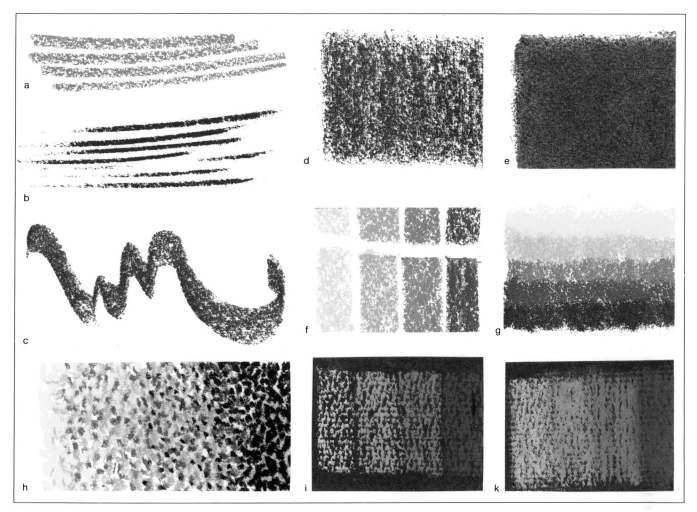

Pastel. True pastel colors consist of highly durable, soft, colored powders (pigments) to which only enough adhesive is added to be able to press them into stick form. A surface covered with pastels has a powdery, satiny texture. Somewhat harder than pastels, of good color intensity and covering ability, are edged decorator chalks. These are very suitable for sketching, but cannot replace the true pastel. This is true to a greater degree for chalk lightly mixed with oil or wax and thus designated as oil or wax pastels (see also page 14).

Pastel colors can only be mixed to a certain extent. Therefore, a relatively large selection of pastels is needed (20 to 100 or more shades, depending on the creative intent).

Surfaces: all types of paper and pasteboard, having an even or slightly roughened surface (handmade and simulated handmade paper, fine sandpaper, French velour paper).

Fixing: pastels must be fixed or mounted under glass so that the glass does not touch the picture. Fixative changes the satiny surface, but it is usually necessary to avoid smudging.

a) Energetic, rhythmic lines with the point of the pastel stick.

b) The same with the sharp, long edge (that emerges with a broad application, as in sketch c).

c) Broad application in linear style.

d) Broad application filling the surface.

e) Broad application rubbed with the finger.

f) Blending colors: pastels do not mix particularly well if they are applied over one another. Every color strip below is a mixture of the colored square above and the color standing immediately to the left. The last layer applied almost completely covers the layers underneath.

g) It is therefore better to apply the colors next to one another. For example, a transition from yellow to red is created by applying orange pastel in between.

h) Optical mixing: the colors to be mixed are not applied over one another, but rather, small points or strokes are placed next to one another. The mixing does not happen on the paper, but through the eye.

i) Bright shades of color on dark paper.

j) The same, but the shades have been rubbed with the fingertip. Blending colors can be most easily achieved by this rubbing technique.

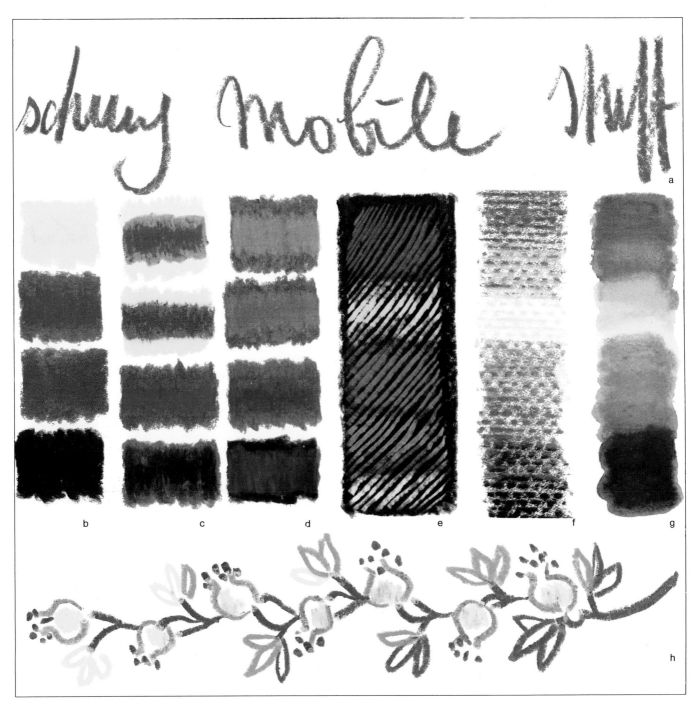

Color Crayons. Wax crayons are suitable, as are all colors in stick form, for writing (sketch a) and linear drawing (sketch h). Fine details and contours are difficult to execute because of the thickness and somewhat adhesive consistency of the crayons—but that is not necessarily a disadvantage.

b) Flat application of a back-and-forth motion of the crayon with firm pressure.

c) Blending colors: dark color on light color. The dark color practically covers the light one.

d) Blending colors: lighter color on dark color. A clear blending of both shades occurs.

e) Scratching technique (grattage): an even layer is applied to the paper (e.g., yellow, red, or even candle wax.) A contrasting layer of color is applied over it (e.g., black). This upper layer is scratched with a sharp object (needle, knitting needle, scraper). The color first applied peeps through the scratched surface.

f) Rubbing technique (frottage): the paper is laid over a relief surface and the texture rubbed through by a back-and-forth motion of the crayon. In this way, very beautiful color blendings can be made.

g) Wax crayons can also be applied to wet paper and can be painted over with a wet brush after a dry application. Watercolor effects can thus be obtained.

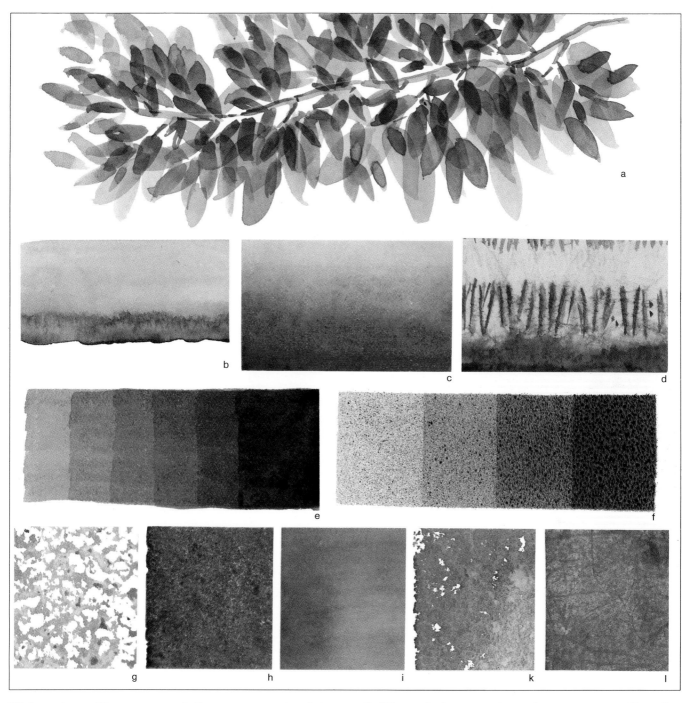

Watercolors. These are nonfading transparent paints using gum or arabic, a vegetable gum, as the binding agent. Watercolors can be bought as shallow cups of compressed blocks or in tubes. They are very good for mixing; a small selection (six to twelve shades) is enough to make many colors. Watercolors are water soluble, both wet and dry, and are generally applied with a natural hairbrush. Surfaces: watercolor papers, Japanese paper, watercolor board. The paper should be taped down; it may be thoroughly moistened on both sides and then stretched on the board.

b) Application of large, even areas of color: taking a lot of liquid on the brush, hold the paper at an angle, so that the color runs together at the bottom edge.

c) Same as (b), but the new color applied is darker.

d) Wet technique: work on damp paper to allow the colors to bleed into one another.

e) Layered application of watercolor: first paint the lightest shade over the entire surface and let it dry. Then apply the next layer with the same or a darker shade, and so on. Also used in sketch a.

f) Spray technique: soak a hard brush (e.g., shoe or toothbrush) with watery paint and either rub it over an even wire grate or drag your thumb across the bristles.

g) Influence of paper structure on the color structure: brush is stroked lightly over large-grained paper.

h) A brush held upright on the same type of paper.

i) Relatively wet brush on very smooth paper.

k) Flatly held brush on sandpaper.

l) Very wet brush on Japanese paper.

a b c d

e f

Acrylic Paints consist of a mixture of colored powder and artificial resin base used as a binding agent. High quality acrylic colors for artists are sold in tubes. The more simple and inexpensive quality is called "binding" or "dispersion" color, and is manufactured as an indoor and outdoor house paint. Acrylic colors, depending on the pigment, can be applied opaquely, in glazes, or with the palette knife. They can be reworked with water while wet, but dry quickly and are totally insoluble once dry. Hair or bristle brushes can be used for painting, but brushes must be thoroughly washed out *before they dry* or they are ruined: don't use expensive brushes. Polymer medium may be used instead of water for greater texture and luminosity. It is sold in gel, gloss, and matte finish. During painting the drying process can be retarded by spraying the painting with a water atomizer, or by mixing the paints with a paint retarder sold especially for this purpose. Acrylic colors that have not been used and dried in the open air are sensitive to temperatures under 8 degrees C.

Painting surfaces: acrylic colors adhere to practically every material, though fatty or oily surfaces ought to be avoided. Very absorbent surfaces (fabric, very dry wood, bark, and cork boards, etc.) should be primed with a special adhesive primer. Stiff paper,

pasteboard, or illustration board are fine. Acrylics do not need varnish.

a) Opacity and glazing ability of acrylic colors; here a light shade on a dark background.

b) Glazing technique: transparent color layers are painted over one another (the under layer should be thoroughly dry). The colors become darker and thicker with each additional layer.

c) Ungraduated color transitions can be executed easily with acrylic, especially if a drying retardant is added to the color.

d) Pointillistic technique: acrylic color is particularly well-suited for this technique because it is quick drying.

e) Pallette knife technique: see "Oil Colors."

f) Impression technique (also called decalcomania): the color is applied to a smooth, nonabsorbent plate (glass, metal, synthetics) and casually distributed with a brush or spatula. Stiff paper is laid over the plate and pressed by rubbing with the hand, then carefully peeled off. The seemingly random forms which emerge can be further interpreted by being drawn or painted over. Acrylic paints are multipurpose and can be worked in a manner similar to opaque and thin tempera paints, opaque watercolors, or oil paints.

Oil Colors consist of nonfading pigments. The binding agent is pure (bleached) linseed, poppy, or sunflower oil. Turpentine, petroleum, resin, or beeswax salve (1 part beeswax melted with 2 parts French turpentine) serve as solvents. Oil colors come in artist's or student's grades, but the artist's quality paint is preferred. Pay attention to the small stars or dots on the tubes which indicate the degree of color permanence. Oil colors are soft, good for stroking, do not run into one another, dry slowly, and can therefore be rubbed easily or removed with a palette knife (e.g., for corrections). A bristle brush and palette knife are used for covering, a soft hairbrush for glazing. The painting ground can be paper, pasteboard, cardboard, fabrics (e.g., canvas stretched over a frame), wood board and wood pulp board. These must be primed.

a) Covering technique: because of the easy spreading and stability of oil colors, even color surfaces can be made easily without a trace of brush strokes. Apply color in vertical strokes, and then brush again horizontally with an empty, damp brush.

b) Single color plus white applied with short, uneven brush strokes. The paint partially mixes on the canvas producing a lively surface of many different shades of color. The brush strokes are not rubbed.

c) Color transition in gradations from light to dark. The shades of color are set next to or under one another.

d) Consistent color transition. Oil color is ideally suited for this. First, apply different shades of the color next to one another. Then rub the darker color into the lighter (or the reverse) with a damp, empty brush using gentle, diagonal brush movements. Finally, work over the entire surface with a clean, slightly damp brush.

e) Optical blending of color: mixing two colors by placing pure shades next to one another in small patches. The respective shades which result depend on the quantitative participation of each color.

f) Palette knife technique: the paint is applied with the edge of a palette knife in horizontal mounds which are then drawn down or sideways over the surface.

g) Glazing technique on white undercoat. Paint is applied in thin layers increasing darkness and depth of the color.

h) Glazing on a monochrome undercoat. Colors can be toned down by a glaze layer.

i) Glazing on a gray-on-gray undercoat (grisaille). The black and white design was painted first. Glazed areas painted over after drying. The picture seems illuminated from the depths.

You can find photographs that inspire creative ideas anywhere: illustrated magazines and newspapers, travel brochures and mail-order catalogs, billboards and display window decorations, food cans and packaging. Everywhere, in fact, where photographs are used.

The Photograph as a Source of Inspiration. Everyday, we look at hundreds of photographs, often without actually seeing them. Indifference is a high price which we are forced to pay for oversupply. But many times our glance holds fast, a photograph is interesting, it seizes us, strikes a resonant chord, arouses our fantasy. Often enough we lack the time to tarry, to ask ourselves just what touched us. Yet the impression returns again and again: you go ten times past a bank where you have no account, secretly tear out a page from a magazine, get brochures of a country to which you will never travel. As incomprehensible or useless as all this may seem to someone else, an image has captured your imagination: a photograph has become the source for artistic inspiration.

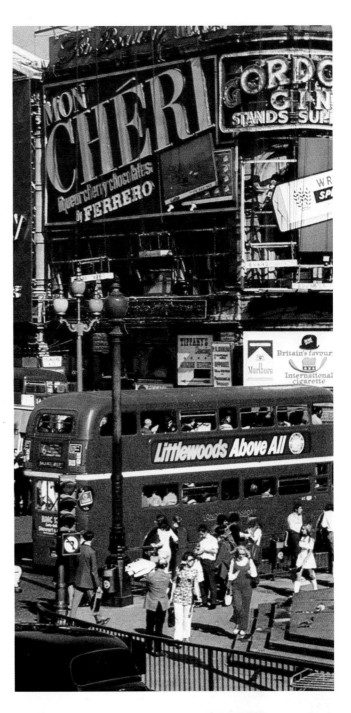

The Photograph as the Result of a "Search for an Image." It is somewhat different to go looking for pictures with the camera. One goes out with certain, even if unclear, preconceptions, following definite intentions. For instance, you want to capture the unmistakeable atmosphere of the city, or a village, or landscape. Perhaps you are interested in fountains, you hope to find a picture juxtaposing old and new, or the ways in which people decorate their windows. You may have been intrigued by glass windows on business streets, with scripts floating on the glass, mannekins, colored light signs, the reflections in the windows of images from the other side of the street, pedestrians, passing cars: a fantastic collage of images that can only be captured with the help of the camera. You might like to investigate the play of light, the forms of shadows on walls, umbrellas, the folds of drapes, the juxtaposition and interplay of light and shadows, any of which might serve as the basis of an abstract composition.

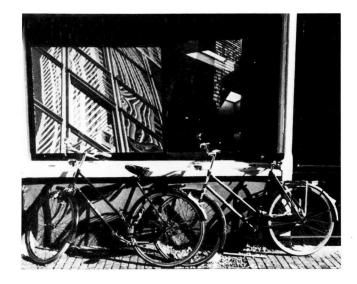

Using Photographs to Create a Composition. A photograph may be used as a first step, much like a preliminary sketch or group of sketches is used, to form a basis for a final drawing or painting. The photograph may contain an interesting detail, or a strong central figure, or a background texture, any image which the artist wishes to cut out and put into the final work. In this case, the photograph needn't be a perfect composition for a painting; the artist will select some of the elements from the photograph and make his own composition.

The illustration at the left shows a complex composition that unites very different elements. Two bicycles lean against a light-blue wall in front of a large window with a dark frame. The bars and spokes of the bicycles are doubled in the shadows, while the shadows make the space between the bicycles and the wall clearly visible. Also of interest is the contrast between the rounded bicycle parts and the absolutely flat black shadow. The artist might choose to use only this part of the photograph for his painting. If so, he might want to take additional photographs of bicycles in similar positions and lighting, in order to vary and to clarify the problem. On the other hand, the very interesting reflections in the windows could serve as the inspiration for numerous other pictures.

The Staged Photograph. In the staged photograph the relationship between the photographer and the image to be photographed is fundamentally different. The photographer creates the picture, arranges the figures, decides the overall construction, details, colors, lighting, etc. Many types of pictures can be staged: still lifes, figure groupings (especially popular before noteworthy backgrounds!), portraits (with infinite variations in expression), even snapshots. Staged photographs are thoroughly legitimate and necessary, and, in such areas as advertising photography, completely indispensible. It is only unpleasant (or laughable) if the staging should be forcibly concealed. (See page 40.)

Technical Manipulation. Every photograph is shaped by the equipment that the photographer uses and how he chooses to use it. In fact, photo-technical means may be used to produce photographs that are highly imaginative departures from the original scene photographed. This can happen both in taking the photograph (for instance, the choice of zoom or fish-eye lense) and in the darkroom. The darkroom offers a wealth of possibilities for variations on the most ordinary negative or slide: the image can be distorted, corrected, restructured, printed by screen process; the color can be totally changed through filters and colored illumination; and contrasts can be sharpened, softened, or reduced to a few tones. Our illustration shows a "posterization" which reduces the continuous scale of countless gray tones (on the negative) to four tonal levels. This abstraction means stronger contrasts (the make-up effect of the eyes, the ruffled collar in front of the light gray face) and a flattening of perspective. This particular photograph might be translated into a linoleum print, a sprayed work, or a drawing in a limited selection of shades of gray.

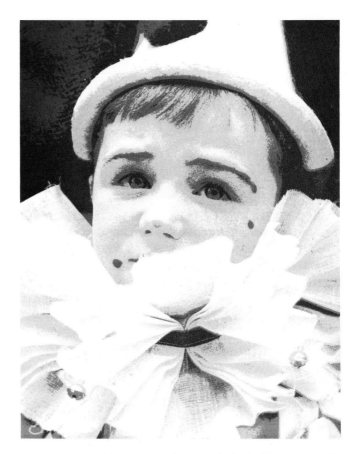

Photo-collage Technique disrupts the unity of the photographic image. Parts from one or several photographs are cut out and glued together to form a new composition which has no correspondence to visible reality. A totally artificial and fantastic world arises that fascinates and confuses us, yet is composed of recognizable objects: a plant composed of human limbs or burst machine parts, a human body made of branches, leaves and blossoms. The world of the collage is not subjugated to the uniform point of view of representative photography. The collage can reconcile images of different, even opposing content, perspective, and space, into new worlds. It is ideally suited for fantastic pictures and drawings. Our illustration shows a "cut collage." A photograph was cut up according to a specific plan (here in the form of concentric circles) and put together in a new way (the circles were turned).

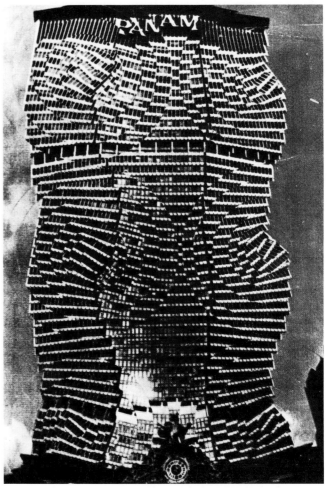

The possibilities to work creatively from photographs are as varied and vast as the number of photographs to be found. The best known, perhaps, is the method of using photography as an aid to more exact rendering and reproduction of the visible world. A photograph does not walk away, does not move a muscle, changes neither lighting nor mood; difficult proportions, foreshortenings and distortions are measurable, traceable (see pages 9 to 11), and enlargeable. Even before the invention of photographs, artists and scholars were experimenting with the *camera obscura,* the predecessor of the photographic camera: Leonardo da Vinci (15th and 16th centuries), Vermeer van Delft (17th century), Canaletto (18th century), perhaps even Caspar David Friedrich (19th century), to name only the most important. Many artists worked from photographs after the invention of photography in the middle of the last century. However, these artists did not wish to produce copies. There are hundreds of portraits, figure compositions, landscapes, genre illustrations, still lifes that were painted from photographs and yet are independent pictures with all the characteristics of artistic creation and a power of expression different from photographs (see page 7). These artists did not imitate the photograph. They worked from photographs as they would work from a model or from nature. Using the object as a reference point or source of inspiration, they attempted to realize their personal interpretations of life in their paintings. Technically, they were interested in translating the photographic image into color, line, light, and shadow. Technical problems of execution were then, and are today, studied with the assistance of photographs: proportions, distortions and foreshortenings, varying illuminations, light and shadow, disintegration of the form through color, the portrayal of plasticity, texture, structure. The challenge of photography to the artist striving for technical exactness has remained constant to the present day.

The ability of photography to capture a moment in time, to arrest the moving and ceaselessly changing images of reality, has made it a rich source for new motifs. It has given new impulse to the presentation of movement, of quickly-changing light reflections (such as light on water), of complicated reflections and counter-reflections (windows, mirrors), the characteristics and textures of materials, of perspectives otherwise difficult to construct, and of momentary human expressions (such as terror, or elation). The effects and influence of the photograph established themselves in many artistic streams of the 19th and 20th centuries: Impressionism, Pointillism, Expressionism, realistic and psychological art, Futurism, Surrealism, Pop-art, even abstract painting which incorporated images from photographs of natural, technical and even microscopic structures.

Artists had used individual aspects of photography for their pictures for over a hundred years before the Photorealists, in the middle of the 1960s, began to examine photography as a whole and complete system of representation. Through as exact a copy as possible, in greatly enlarged format, the Photorealists brought to light (and consciousness) the fact that photography is an independently creative technique that does not illustrate reality as objectively and as realistically as had been previously thought. Like every other artistic or graphic technique, photography has its own materially determined characteristics: it is dependent on technical apparatus and chemical processes on the one hand, and on the intention and ability of the photographer on the other. Thus, photography emerges a wholly specific means of representation, rendering images of the world that can be obtained through no other technique (see "Introduction"). We have become acclimatized, so used to standardized mass-produced photographic images, that we have forgotten that these too are departures from visible reality. To the Photorealist, painting and drawing from photographs makes this fact undeniably clear—especially for the artist himself. Whoever paints photorealistically does not attempt to convert the photograph into artistic images, but strives to work out, perhaps even to reinforce, what is typically photographic (e.g., plunging lines, blurriness, flatness, reflected colors, alienating light temperature, sectionalism, etc.). In this creative work, which this book hopes to inspire, it becomes clear that there is little in Photorealistic painting that deals with mere copying, as was the case with the Old Masters of the 19th century.

At first glance it would seem that this picture was photorealistically conceived, the photograph and the picture are so similar. Don't forget, however, that the photograph and the picture were both rephotographed for reproduction in this book. This has brought them closer together than they actually were in their original states. With a second look, however, we notice that the artist has chosen to focus on the model, simplify the chair, and use an abstract texture in the background. For the background, one can actually see the drawing technique employed: hatching with a soft pencil, rubbed with an eraser. The distinct rendering of the background, apart from the unit of the child and bench, is an artistic choice which varies from the unity of the photograph. Specific elements are emphasized: the new fabric of the dress appears more stiff and wrinkled than in the photograph; the lacquered cast iron parts of the chair are more clearly differentiated from the painted wood slats; the obviously new uncreased shoes have a pretentious quality; the tender skin of the child is livelier and less two dimensional than in the photograph. The picture, drawn with pencils of different hardness (HB and 2B) and an eraser, makes good use of the white paper as a color. It shows that gray tones can act artistically.

Concerning Technique: First apply the gray tones in soft hatchings; avoid sharply etched lines. If the shading is still not dark enough, an additional layer of hatching may be added. This layering approach is better than a single layer of hatching drawn with great pressure. Next, rub with an eraser, finger or rubbing stick to soften the lines. If necessary, erase particularly bright spots that appear in the gray areas. Soft eraser sticks that can be sharpened like a pencil allow great exactness. Work from light to dark; do not draw the darkest shades until the very end as these will not be rubbed.

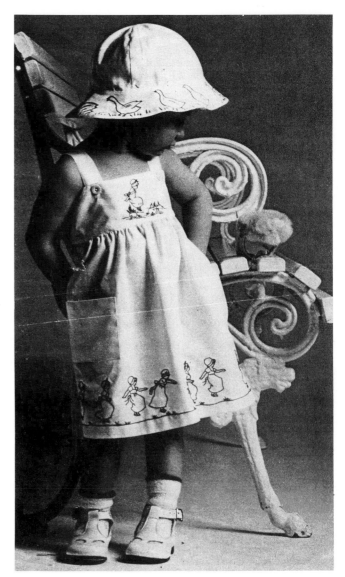

From *Brigitte* magazine (Clipping 15 × 20cm).

Remo Copparini: Young Girl with Garden Chair, pencil, 1979 (30 × 42 cm).

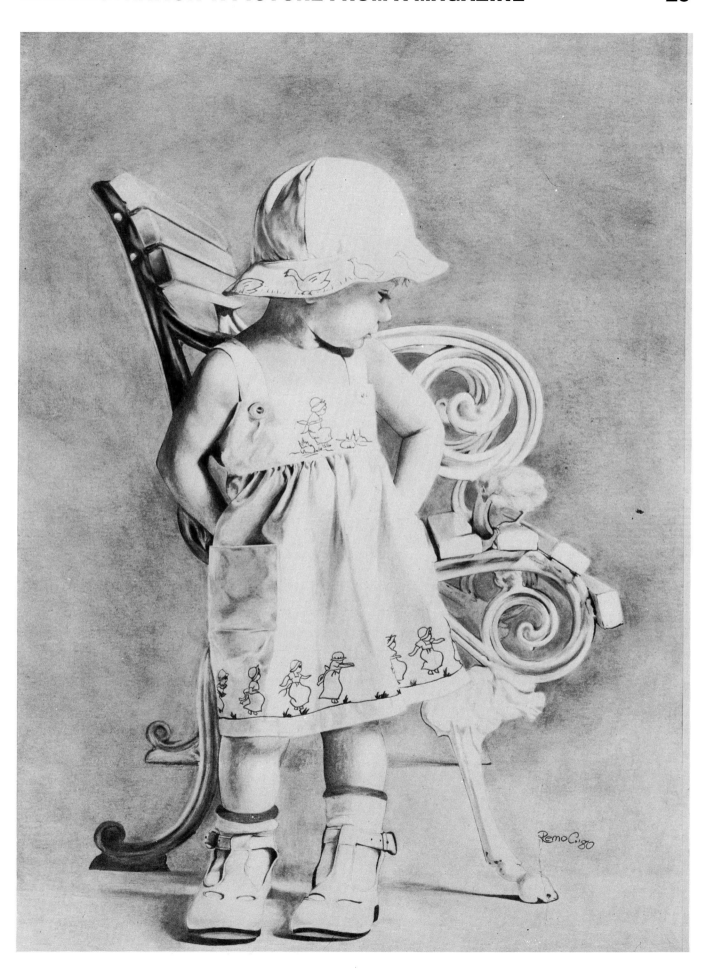

Chalk tuff is a rock with an extremely porous, sponge-like structure, formed through the compression of volcanic ash. Sawed into blocks or plates, its characteristic and fantastic inner life comes to light. Holes, grooves, ducts, gullies form a chaotic labyrinth that appears to be inhabited with sinister little skeletons, gnomes and bony spiders. There is no regularity; every bend, every opening and offshoot is unexpected: a fascinating, irregular, miniature landscape.

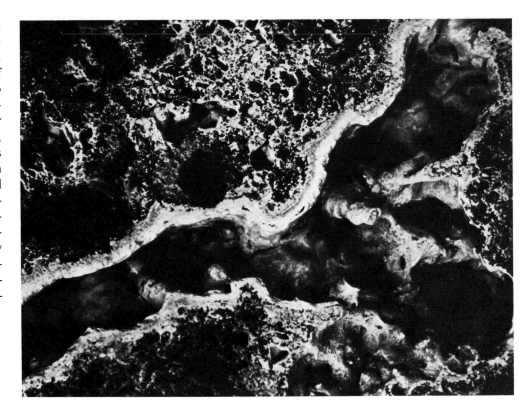

Step 1. Four decalcomanias (acrylic color, impression technique). The joy of discovery grows into the wish to make such a landscape emerge on paper, not a reproduction of this piece of stone exactly, but, a landscape of mountains, gullies, rifts, rubble and craters that are random and irregular and will send the fantasy of the observer on a journey as exciting as our photograph. Naturally, it is difficult to put something so new, even unearthly, on paper. The random results of the impression technique (decalcomania, described on page 22) come to our aid. Forms will emerge that, with some practice, can be influenced, but by and large, are random.

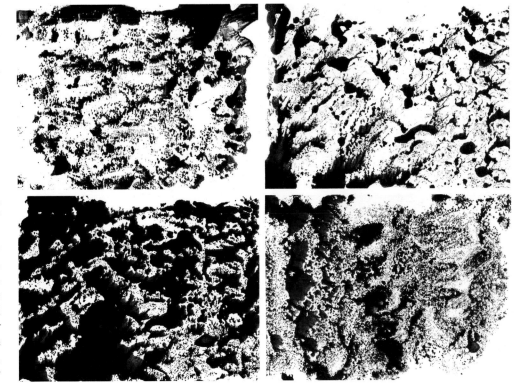

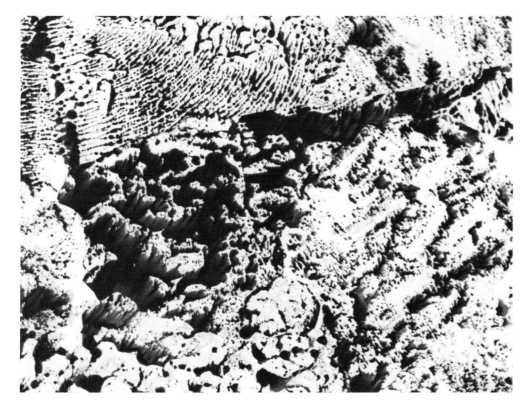

Step 2. Collage from decalcomania parts. The four pictures in Step 1 show confusing, complex structures that can be interpreted as landscapes: aerial photographs of the Grand Canyon, glaciers, stony deserts. One gets the impression of vertically incised valleys tearing and splitting a mountain range. Portions of the decalcomanias from Step 1 were added to this picture using a collage technique with some over-drawing. Care was taken that the almost vertical "mountain walls" all ran in the same direction for the success of the composition.

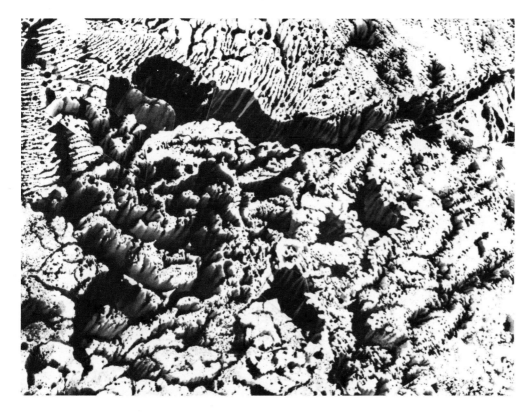

Step 3. Collage painted over and retrimmed. For both work processes, pasting together (collage), and overpainting, the artist has allowed himself to feel the compelling rhythms of this random organic landscape, and to follow those feelings. Only the spatial merging of the individual forms should be ordered, so that the artist's hand—cutting and pasting, strokes of the paint brush—does not intrude on this seemingly nonhuman world.

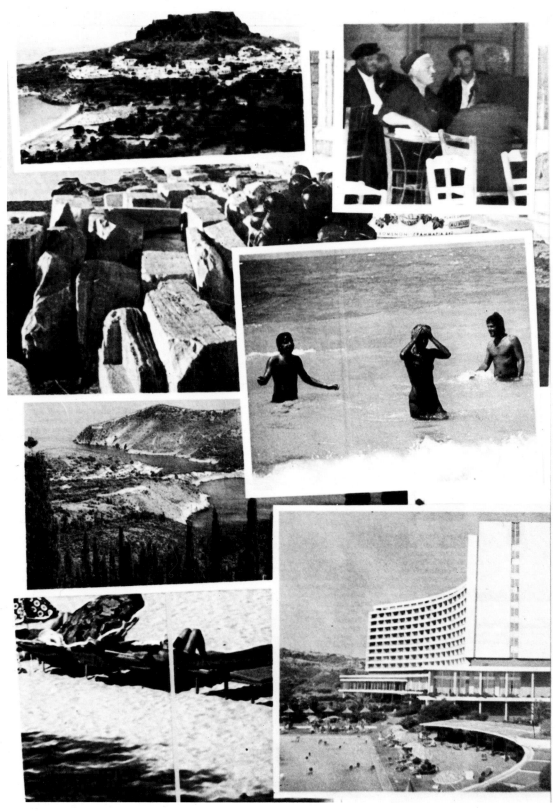

Travel in foreign countries is an old and ever-popular human dream. Books and illustrations have always nourished this dream. Today, photographs, slides, magazines, television, films, lectures, and of course, travel brochures, add to this interest. Sometimes the bad printing quality in these mass-produced advertisements has its own esthetic quality (see pages 42, 45, 58, 66, 78). *Portrait of a Country* is an attempt to show samples of such travel brochure illustrations. These selections, when put together, produce something of the imagined or experienced atmosphere of a country. Cliché-ridden tourist attractions should be avoided.

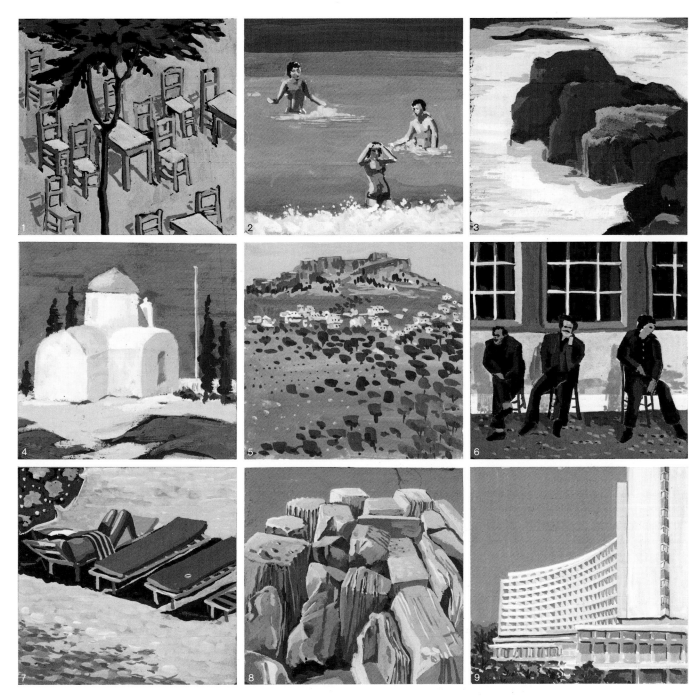

Nine compositional sketches with opaque watercolor. Each picture should exist as a self-contained, well-balanced composition.

1. The diagonal arrangement of the chairs in the background is set against the strong vertical division of the canvas.

2. The figures form a triangular composition organizing the horizontal bands.

3. Diagonal composition.

4. Strong central pyramid image and repetition of triangular shapes.

5. Image constructed from horizontal bands.

6. Overlapping horizontals and verticals organize the composition.

7. Oblique thrust and unusual cropping of images.

8. Obtuse pyramid form with dissecting lines.

9. Receding diagonal divides the surface.

To understand the problems of color with which photographers, and to a still greater extent the Photorealists, are concerned, it is useful to have some knowledge of the chemical processes of color photography. Modern color film consists of three light-sensitive layers: a yellow, a magenta, and a cyan layer. When these three colors are mixed in a substractive manner, in other words,when they are used as a color filter for white light, all the colors of the visible spectrum can be created (see the illustrations on page 57). The yellow layer of the film reacts on all blue, the magenta layer on all green, the cyan layer on all red light rays that are collected through the lens. Turning to our example: the blue spots of the butterfly's wings are held fast in the yellow layer, the green surfaces of the background appear in the magenta layer, and the red stripes of the butterfly are in the cyan layer of the film. In enlarging, the same process is repeated in the reverse manner, so that the "natural" colors appear in the final photograph. The characteristics of photographic color are influenced by a variety of factors. First of all, by the quality of the photographic equipment and developing processes that are used. Secondly, each type of color film is sensitive to a specific type of light, for instance, to daylight, or to artificial light. And within these categories arise an infinite variety of illuminations. For example, in the morning the light contains more blue parts, while in the evening there is more red.

The human eye is not as sensitive to these color temperatures (a white house is perceived as white in the morning or the evening), while the film registers them unerringly. Flashes of color which may escape the human eye are made fast on the photograph. Therefore, when developing pictures the laboratory will attempt to neutralize any flashes of color with the use of filters. At this point, photographic technique begins to follow its own aesthetic norms that have only little to do with natural perception. For the required color filter will alter all the colors of the picture at once, minimizing sharp contrasts in light and dark and creating a strong color harmony. The pictures may have a *beautiful* effect, even if the motif does not have this characteristic.

This generalizing of contrast in color and tonality is especially true when developing in the large modern print machines used for the work of most amateur photographers. Working for a mass market, many photographs will not receive the filtration most advantageous to their particular characteristics. The filtration of the machines is set for a medium shade of gray. The admixture of colors that produce neutral gray is known in color theory as *harmonic*. Millions of photographs go through the same filtering. Therefore, the specific requirements of the individual picture, its specific illumination, color tonality and contrast are diluted in favor of a statistically medium quality to accomodate all the photographs processed.

Photography as a creative technique should not, therefore, be blamed for being unable to reproduce what the eye sees. People overwhelmed with photographic illustrations often do not notice the harmonizing and idealizing inherent in photographic representation—even while praising the documentary genuineness of the media. There is a danger of photographic methods of illustration acquiring, through habit, an unspoken, perhaps even unknown, aesthetic norm, that will make people impatient, or at least helpless, with all other visual art forms that do not look like a photograph—including photography itself.

The Special Characteristics of 3 and 4 Color Printing. These considerations naturally touch on all photographic illustrations, which are then multiplied in the technique of multicolor printing. The mechanics of color mixing are quite similar in three and four color printing and photography. Screened color sections are made from color photographs with the help of photography: a yellow, a magenta-red, a cyan-blue, and often a black. The quantitative parts of the colors are transferred through the screen in colored dots of different sizes. Printing blocks are then made with these sections. Through exact overprinting, tonality arises which is seemingly similar to that of the photograph in that where the colored dots are juxtaposed, they are blended by the eye.

Areas of the image left uncovered by the dots will appear lighter in the same manner. Where color dots overlap, they change shade and appear darker. Dots of all three colors superimposed over one another will produce a blackish gray tone, leaving them lacking the desired color brilliance. To control these visual effects created by the color dots, the three-color printing process is supplemented by a black printing layer, which lends the colors luminosity and depth.

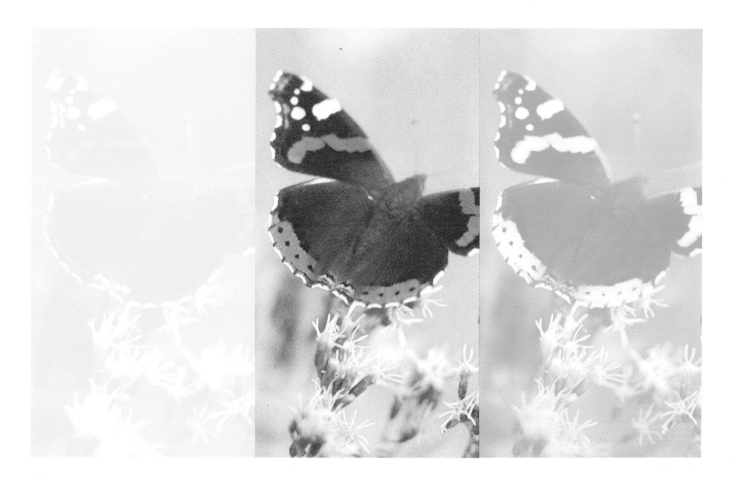

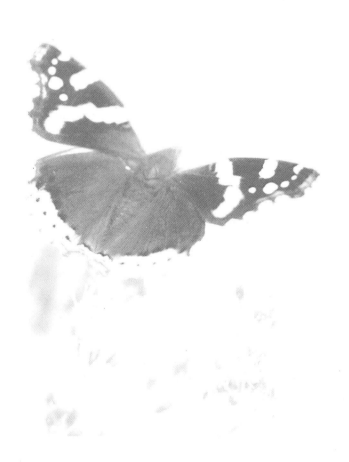

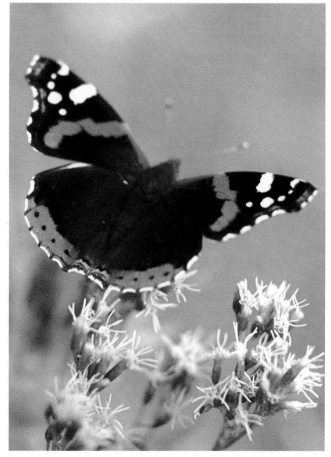

It is always fascinating when looking at plants standing next to one another—a section of meadow, a stand of trees, a vegetable field—to observe the many shades of green our eye can distinguish. It is exactly this wealth that makes the artist's job difficult. A photograph can be helpful in overcoming this difficulty, for it substantially reduces the abundant variations and nuances of color.

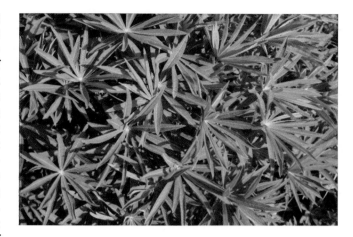

Step 1. Here the artist has looked for a means of presentation that would clarify the confusing optical impression. The number and arrangement of the individual plants was less important than finding a means of rendering their impact and feeling. A dense, compact, seemingly random composition was achieved through gradual layering of a repeated shape painted in shades from dark to light. The layer closest to the ground was painted in the darkest shade of green. The individual rosettes were rendered completely, although parts of them were subsequently covered. A quick-drying opaque paint is best for this manner of execution (tempera, acrylic, opaque watercolor). Each layer must be completely dry before the next is painted.

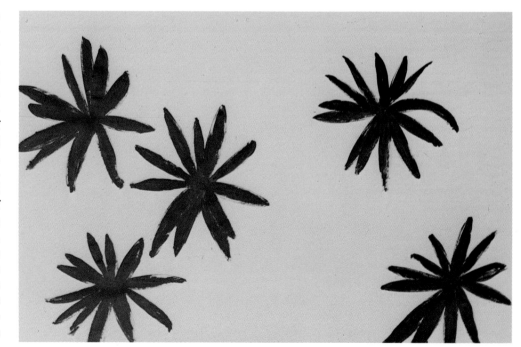

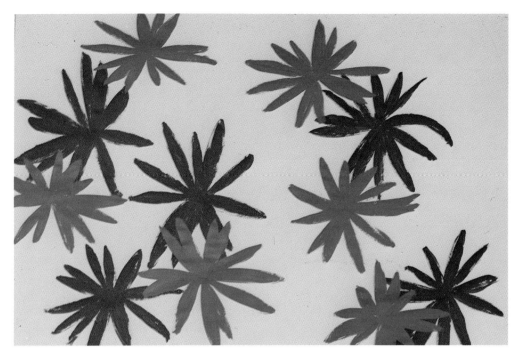

Step 2. Three more layers of leaves were added, each in a slightly lighter shade of green. The empty space was gradually filled, always allowing parts of the darker, bottom leaves to show through.

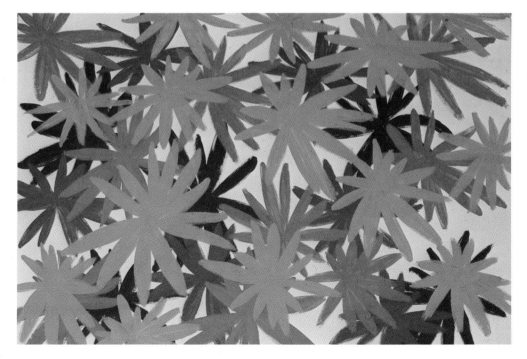

Step 3. The four over-lying shades of green have created an impression of depth and space. The brightest leaves, not covered by another layer, clearly lie on top, closest to the onlooker.

Step 4. The background has been filled in, in dark somber tones which do not compete with the rich pattern of the leaves, nor press forward optically. As the green of the lowest layer of leaves is quite deep, a brown was used for the background. Varying the brown adds interest and keeps the surface from appearing too flat. The shades of brown are lighter at the edge of the painting and become increasingly darker toward the middle. This gives the painting an increased sense of depth.

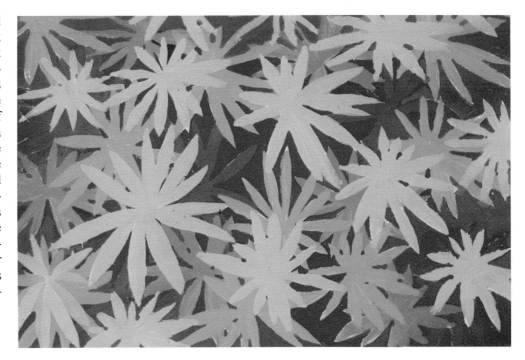

Step 5. In the final stage the leaves were worked over, once again. The positions of the individual leaves in the complete rosettes, and of the under layers are more clearly differentiated. This is achieved with the help of lighter and darker, and also cooler and warmer shades of green—lighter shades for the upper layers, darker shades for the lower layers. Though the scale of colors was greatly reduced, compared to the photograph, the effect of the picture is neither monochromatic nor flat. The picture conveys the impression of a rich gradation of green, and a clear, limited spatiality which corresponds to the compact texture so intriguing in the photograph.

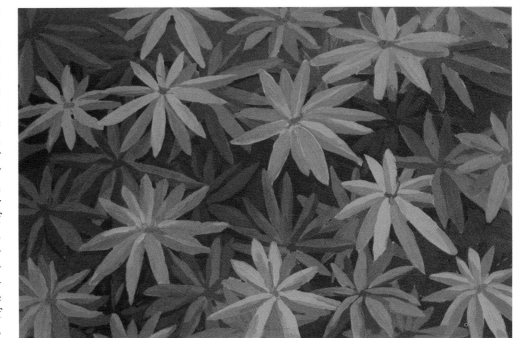

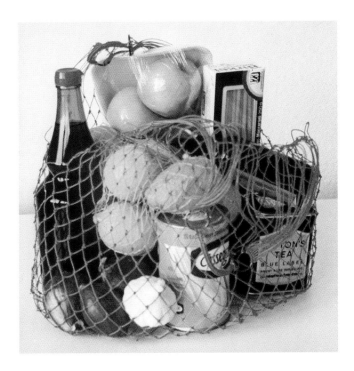

Often, it is the everyday objects that yield the most unusual and interesting images. A mesh shopping bag filled with groceries: fruits, both round and long; cylindrical and rectangularly shaped objects; surfaces that glisten, gnarl, reflect; colored metals; transparent glass; rippled cellophane; printed letters and scripts. The mesh net draws a contour around this random cluster of objects to form a pyramid. There are strong contrasting colors and values. The individual objects are easily recognizable inside the larger shape. The darker colors on the outside make the plasticity of the total form more visible against the light background.

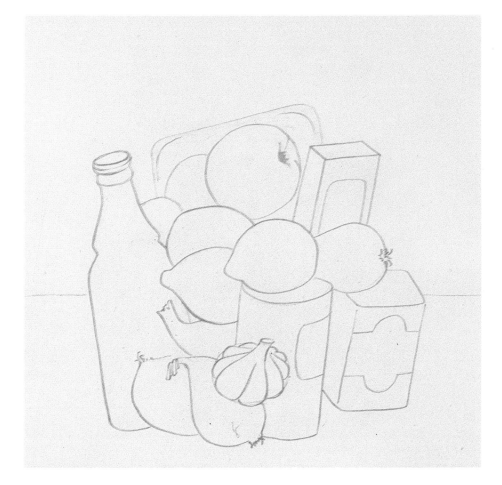

Step 1. The preliminary drawing is very austere and linear. Contour lines describe the objects and delineate color boundaries. The lines are relatively uniform. This layout drawing will serve as a foundation for all future work on the painting.

Step 2. The objects are painted in flat unmodeled shapes to establish their relationships in terms of color and value. Tempera colors work well here, and their quick-drying opacity allows the gradual layering used in this painting. The onions, and especially the cloves of garlic, were intentionally painted in a darker shade so the artist can mold them with lighter shades later on. As in Demonstration 4, paint is applied in layers from dark to light—darks recede, lights come forward.

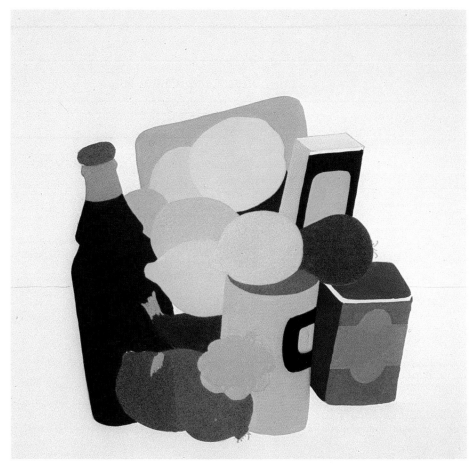

Step 3. Molding, shading, structuring, and the reflections on the bottle are added. The reflections on the bottle and the shadow on the tea canister are painted as unified, sharply-bounded planes. Brush strokes that follow the form create volume in the apples, onions, lemons, and garlic. Gradual color transitions produce volume in the noodle box and food can. The total color resonance of the picture is now distinctly presented and differentiated. The style of painting is still flat and the lightest color each object requires has still not been filled in. Further articulations of the forms and fine shading are saved for the final steps.

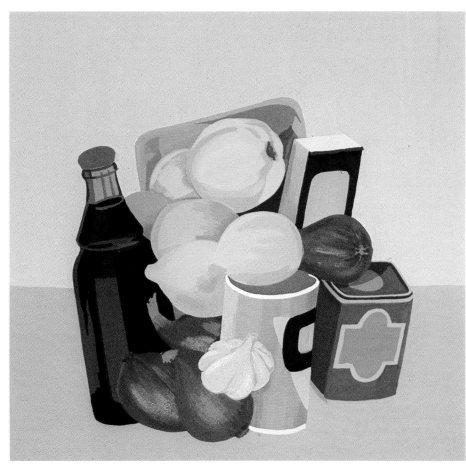

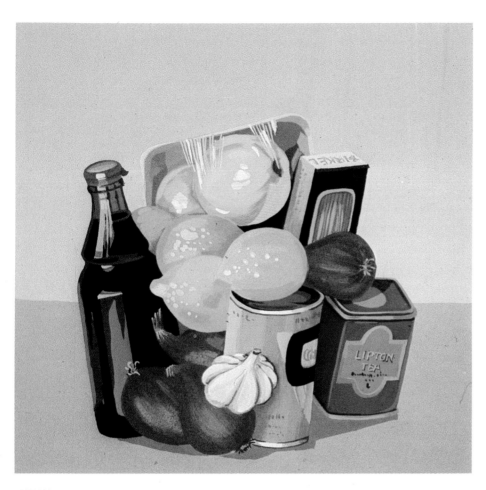

Step 4. Further details are added: the roots and stems of the onions, inscriptions on the cans, noodles in the window of the box, highlights on the bottle, apples, plastic wrap, and lemons. The question arises whether to paint the highlights as brightly and conspicuously as they appear in the photograph. There they are so large and white, that they tend to obscure the forms and actually exaggerate the natural reflective ability of glass and plastic wrap. The artist decided not to conceal the fact that the picture was painted from a photograph. More in the vein of the Photorealists, he chose to reinforce typically photographic elements.

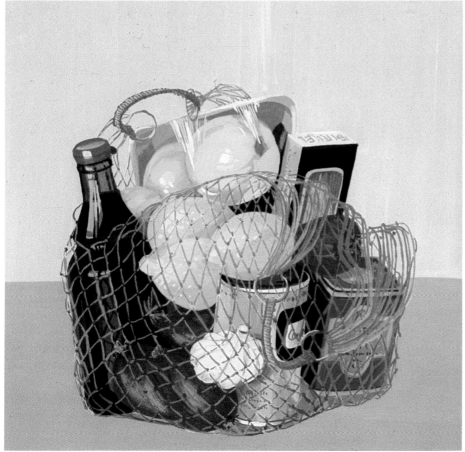

Step 5. Finally the net is painted in opaque paint. In contrast to the photograph it is somewhat simplified. The color modulations of the lines and the darker painted knots are important. It is also important to show the tension of the net; this was made more pronounced by exaggerating the spaces between the narrow and broad mesh. One final word about the amount of work required: there are no tips here for fast work; much concentration and patience are required to complete this last step.

A photograph like those that are shot a thousand times a day. Here, a group of friends have their picture taken while skiing. The great elevation (about 3000 m above sea level) makes the sky and shadows appear deep blue, and the colors of the clothing particularly saturated and intense. The snow reflects the color of the sky in a violet-toned gray, and, except for a few tiny brown spots, the foreground and background of the landscape have no other color. The brightly colored clothing glows against the white ground; sky, shadows, reflections and snow bind them into the blue-white resonance of the composition.

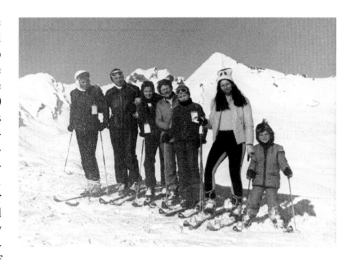

Step 1. The scene is bathed in light. A considerable area of the photograph is pure white or off-white. This, bright, weightless, quality has inspired the artist to use watercolors, a medium which makes good use of the whiteness of the paper itself. The distortions and false proportions of the figures may be disturbing to those who strive for a completely realistic presentation. The artist begins with a preliminary pencil sketch.

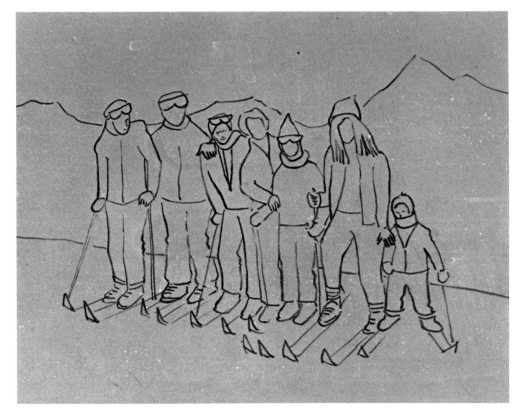

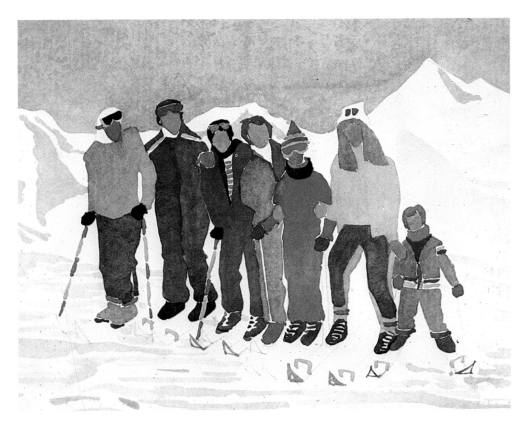

Step 2. The paper, a good drawing paper, is evenly and lightly roughened with a fine sandpaper. This will give the thin watercolor more support. As a result, the paint has a velvety, powerful effect and forms no unpleasant color edges. The lines of the preliminary sketch are still visible. First the sky is painted. Fluid paint that is not too thin is applied with downward strokes on the stretched paper (see page 21). The edge of the mountains is executed with a parallel brush stroke, which catches any superfluous liquid. Textures in the snow are indicated in loose patches. Faces, hair and clothing are colorful and not too dark.

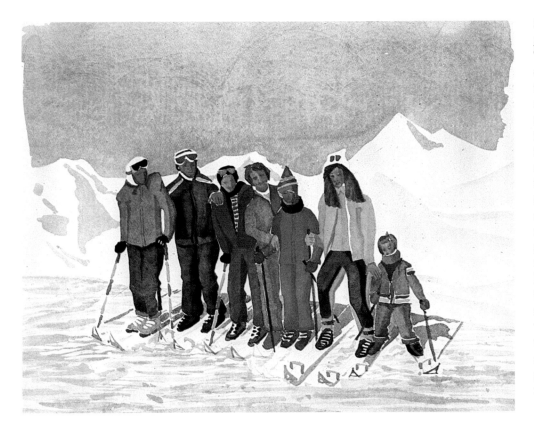

Step 3. Now the figures are graphically worked out. The intention is only to indicate their plasticity, not to emphasize it too strongly. The same shades are again applied after the first coats dry; this deepens the colors and makes them darker. As the light comes from the left front, the shadows must be painted on the right side of the figures (as seen in the photograph). Last of all, the blue shadows are painted; they have the important function of connecting the strongly contrasting figures with one another and with the background. As the last step, more definition is given to the snow structure in the foreground.

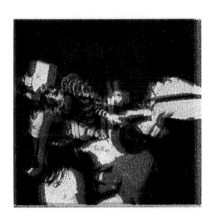

This postage-stamp-size print (2.5 x 2.3 cm) comes from a travel brochure. From a printing and advertising point of view it is technically flawed, but it is exactly this flaw that makes it so interesting for the artist. The individual color plates, yellow, red, blue, and black, were not set exactly over one another during printing. The images are therefore difficult to recognize, but this much can be seen: a dark room, glaringly and colorfully illuminated people (a pianist? a singer?), a few undefined objects in the background. With this juxtaposition of darkness and bright color, that even contains white, we are clearly dealing with artificial, colored illumination. The effects of the colored light have been exaggerated by the printing error: because of the shift, the colors are not or are barely mixed and come clearly into view.

Step 1. For this picture the artist chose wax crayons because of their powerful, saturated, and glossy tonality. The relatively limited color-mixing capacity of wax crayons is not only sufficient for creating this color phenomenon, but corresponds to it in a particular way. To help compose the picture, the print, as well as the drawing surface, were divided into squares 6 x 6. We begin with the brightest, purest reds which are largely unmixed. The color is applied with a kind of writing rhythm, back and forth, with strong pressure. This animates the color surfaces in contrast to the quiet surfaces of the print. It will also make possible a better interlocking of the strong contrasting shades.

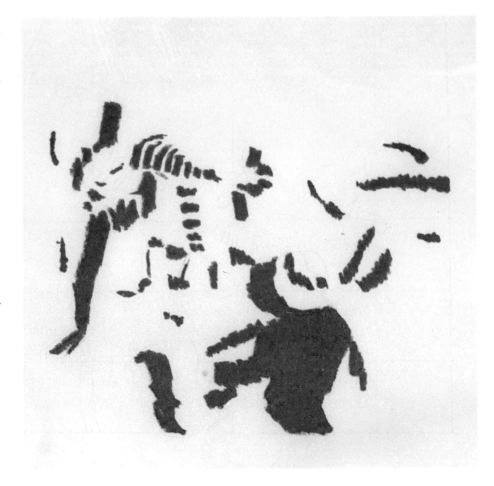

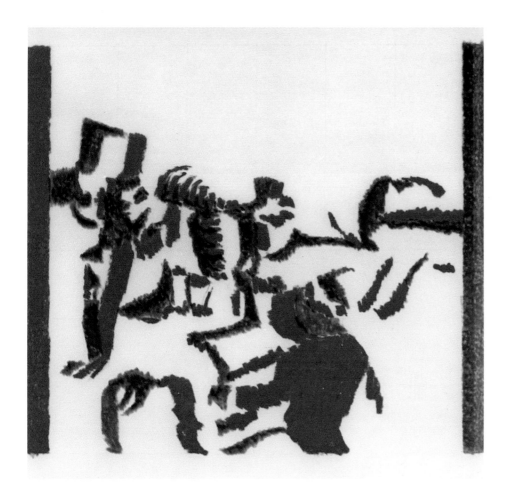

Step 2. The blue areas are applied in the same way, both those that will remain unmixed and uncovered as well as those that will be changed to green when yellow is added. The written character of the application is retained.

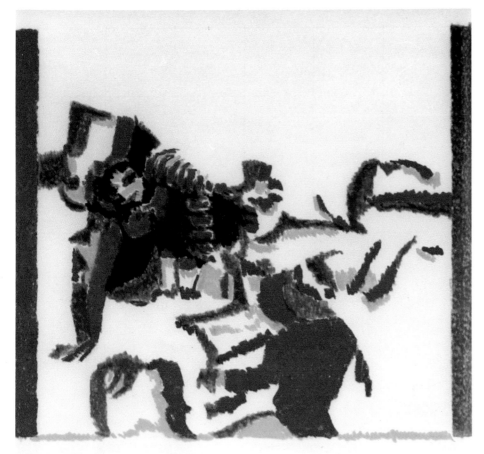

Step 3. After the green areas have been painted in by covering the blue with yellow, the pure yellow surfaces are applied. The final color, black, is begun on particularly accentuated areas. It turns out that the black has a somewhat hard and lifeless effect when applied directly to the white paper. The artist compensates for this in the next step.

Step 4. Looking at the photographic print through a magnifying glass, we notice that a pebbly, textured undercolor is protruding through the large black surfaces. In this step, therefore, all white surfaces that are to be covered with black are undercoated with green (left edge), blue, or red.

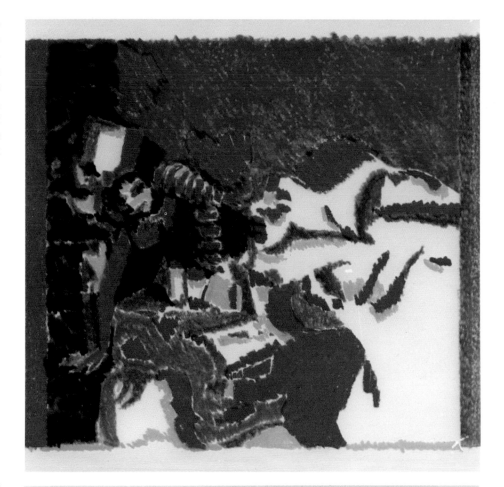

Step 5. Finally, the background is filled in with black. The written character of the application is retained. The undercoat is not completely covered, so that blue, green, and red break through in random specks. Thus, the black acquires colorful nuances which bind together all the colors of the composition. At the very end a few blue spots are placed in the still somewhat large white areas. In contrast to the print, the drawn picture is of great dynamism, and the vibrant colors and shapes make a composition which does not depend on recognizeable images. We almost have a nonobjective, abstract creation.

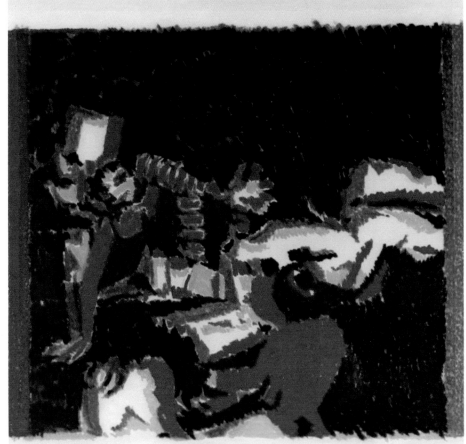

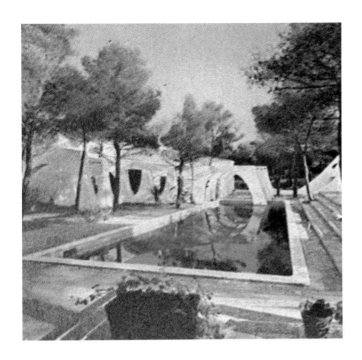

It is not always easy to explain why a photograph or print, which at first glance seems banal and of only average technical quality, unexpectedly strikes a resonant cord in the observer. The artist of this work was roused to transform the hazy colors of the tiny print (4.5 x 4.5 cm) into a clear, colorful composition.

The picture was enlarged by the grid procedure (page 9) to 18 x 18 cm. Print and canvas were each divided into squares 9 x 9, the canvas then executed square by square, line by line. A repetition of the individual steps can be dispensed with here. The painting techniques will be discussed in the enlarged sections below. The picture was painted with opaque watercolors (designer colors or gouache). This color medium mixes well for any shade desired, but subtle color transitions are difficult to execute. Therefore, the color shades were placed next to one another; there is no "bleeding" or color mixing on the canvas. For example, the crowns of the trees were rendered with a buildup of numerous clear shades of color which blend together in soft irregular forms.

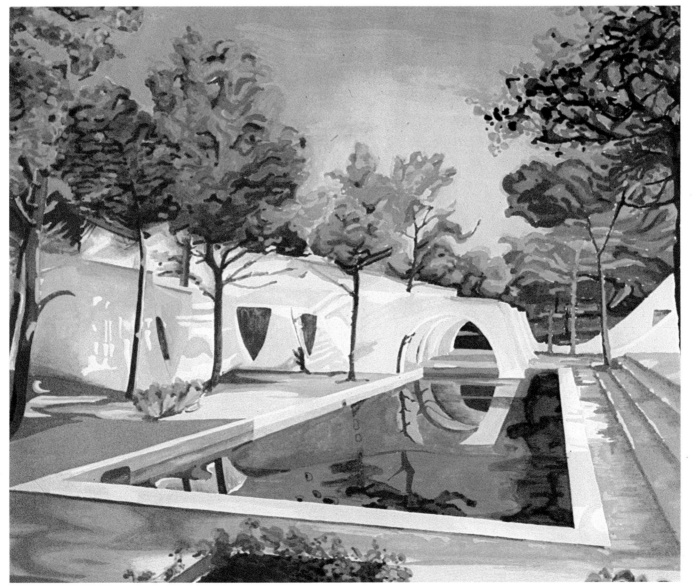

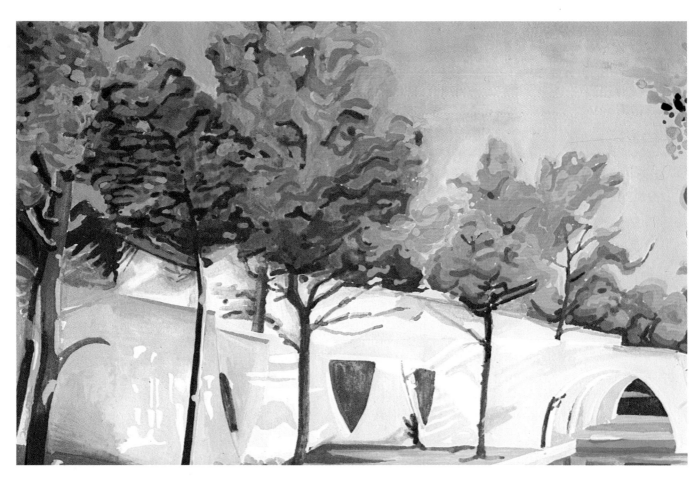

Two different techniques have been used to render the trees. For the crown of the tree second from the left, unified flat color was applied first in the predominent color—here, a warm olive. After this first layer had dried, small color spots—dark olive, dark brown, and blue—were laid over the first. For the group of trees in the right background, tiny spots of different colors were placed next to one another. The paint was used rather thickly. With the first technique described, more formal, delineated exactness is obtainable. In contrast, the second method offers the possibility of a freer, rhythmical, moving color creation.

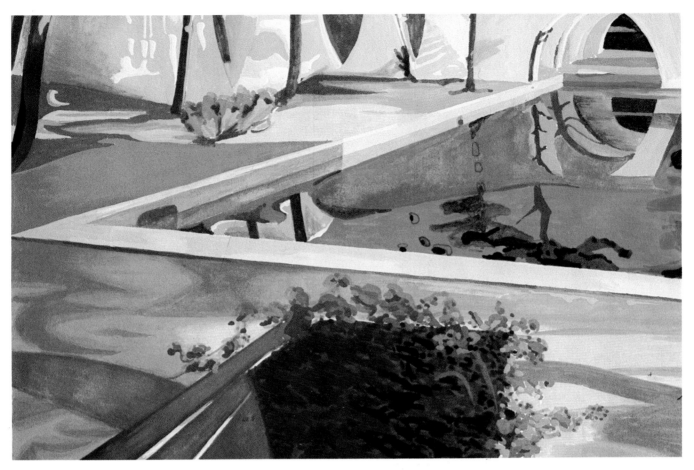

The composition of this illustration, like the larger picture from which it is drawn, contrasts small, delicate elements (trees and flowers in the foreground) and large, sweeping color planes (sky, water, houses, ground). To integrate these contrasting elements into a unified composition, the artist has divided the canvas into large textured areas: the blue water, the white pavillions, the brown pathway, the green trees, and the blue sky. It is interesting to note that the scene is actually clearer and more easily recognizable in the artist's rendering than in the original photograph. Here, the colors are more limpid and cool, and the total effect is more inviting.

Reflections in moving water are always a source of delight. To capture their fleeting beauty on the canvas is difficult and challenging for the artist. A photograph, or a series of photographs, because it arrests this fluid, moving vision in a moment of time, can give insights into the typical form and pattern of reflections on water: how they arise, change, and dissolve. In our example we deal with a moving reflection; the lacy, sun-drenched facade of a building in Venice is practically dematerialized in the rippling water. The photographic image need not be transferred exactly, but can give rise to a freely rendered artistic interpretation of this intriguing phenomenon.

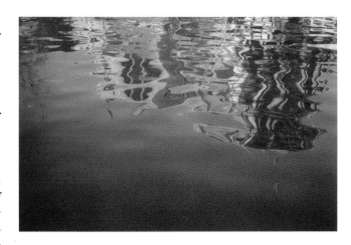

Step 1. The picture is executed with acrylic colors. They allow a free application of large planes, since they are opaque and dry quickly. Instead of a preliminary sketch the most important color forms are painted in large patches. The differentiated forms and more subtle color transitions are reduced to single color surfaces. Thus, the undercoat already contains the chief elements of the composition, as well as the color harmony.

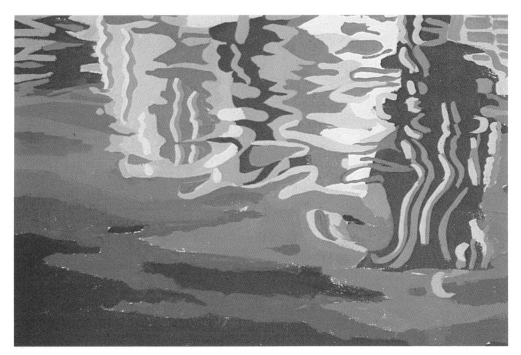

Step 2. Colors and forms are further differentiated with an opaque paint application. The green surfaces are thoroughly worked with fine ochre, light gray, and blue strokes; the brownish rose area shimmers with movement with the addition of brick-red spots and snakelike lines; dark and light red-brown spots are dynamically bound with a flowing ochre zone. Some architectural details are already recognizable. Columns, window frames, and partitions, are continuously broken suggesting the ripples in the surface of water.

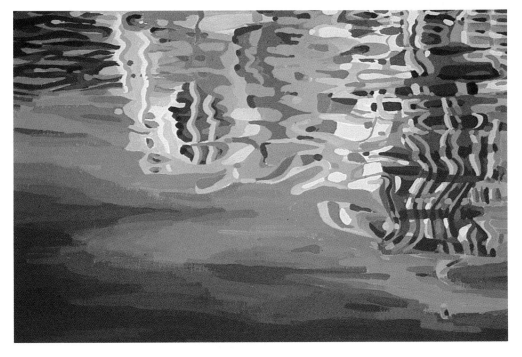

Step 3. More color spots are added to the entire picture further fragmenting the reflected image. The blue patches of the water that are still strongly demarcated, are joined more closely together with the addition of an intermediary green. A wash of dark color is drawn over much of the water using a fine round hairbrush. All edges are softened. The lightest and darkest tones (whitish gray, blackish green) are only added at this final stage of the painting. They give the color a glittering brilliance and depth.

Optical distortions and foreshortenings can present plenty of problems for the less experienced artist. Remember the widespread cliché of the artist carrying his pencil before him with outstretched arm, viewing his surroundings through squinted eyes! Apart from its effect on bystanders, the artistic merits of such an aid to drawing are questionable. Today, it is not that important that a recreational artist be able to master the presentation of optical distortions and foreshortenings. Nevertheless, these phenomena are always very interesting motifs.

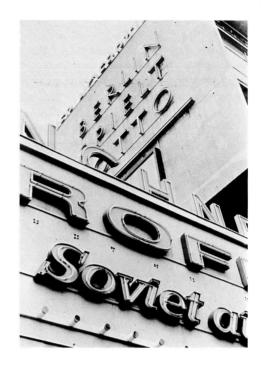

Contour Drawing in Pencil. When learning to understand optical distortions and foreshortening, it is best to avoid the problem of rendering either the human body (especially in motion—athletes, dancers, fighters) or animals. Geometric and architectural subjects, since they are composed primarily of straight lines, are especially well suited for beginning studies in perspective. There are many interesting views to be found in urban skyscraper architecture. The photography shown here was shot from the ground upward, a difficult perspective to draw. However, the straight, geometric lines running right off the edge of the paper can be measured. So for the first step, the artist constructs a simple line drawing with the aid of a ruler and protractor. If the photograph were large enough, it would be possible to make a tracing.

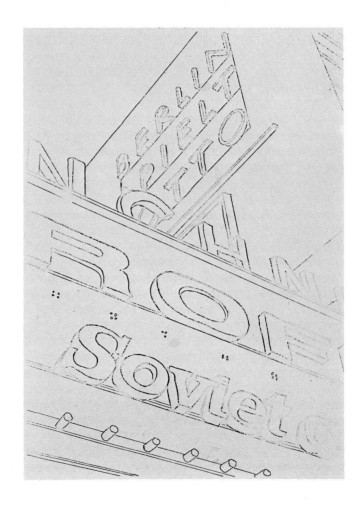

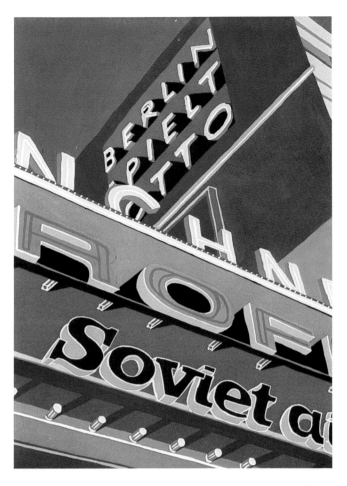

1st Variation. In this interpretation of the black and white photograph, the artist has chosen a color composition of strong contrasts in dark and light. The sky and upper wall are painted in very dark colors: gray-violet, blue-black, dark green. The lettering and the chain of light bulbs are painted bright luminous shades: white, yellow, and violet. The surfaces immediately next to the letters are kept in medium tones: red in warmer and cooler shades. Through these color choices, the feeling of night and illumination with neon lights is achieved. The light emanating from the letters illuminates the immediate surroundings, making a stark contrast with the unlit surfaces. The light violet wall of windows in the top right-hand corner suggests the reflection from a strong light across the street. As small as this area is, it contributes considerably to the atmosphere and spatial relationships of the picture.

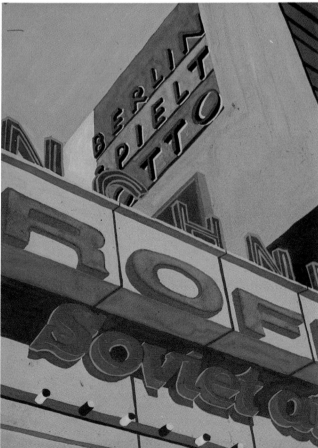

2nd Variation: This interpretation has a very different feeling. It might be considered the daytime view. The walls in rose and ochre are light and luminous, while the dark letters stand out in contrast. But the letters do not give the impression of illumination: either they are not neon lights, or the power has not been turned on. Comparing the two versions points up the different effects which can be achieved through color. It would be interesting to see a third variation in which the letters of the first variation were painted against the walls of the second.

Black and white photographs are excellent models for experimenting with variations in color.

This is the window of a bakery in Amsterdam photographed from the street. The sun was shining and the Venetian blinds had been lowered, perhaps to protect the baked goods from the heat. The fancy script letters on the windowpane are repeated in a broken shadow across the slats. Apparently, traffic signs were mounted on the corner of the building, just to the left of the window, which cast their shadows across the pane of glass. The relief of the wall—hollow grooves between broad rows of stones—is seen as a thick vertical shadow on the green blinds. The opposite side of the street is reflected in the windowpane: the bare branches of a tree, a roof and a chimney, a broad gap between two houses. The shadows create depth and space in the picture.

Step 1. This photograph inspired a Photorealistic execution. The grid was selected as the enlarging method because it promised the greatest exactitude. The picture was painted in oil colors to best capture the luster of the delicate colors in bright sunlight. Also, oil colors are the best paints for rendering flowing color transitions. Work was begun on the left side of the picture.

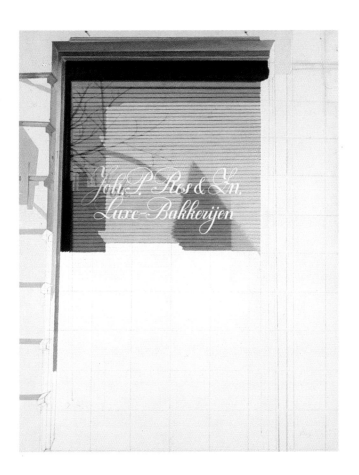

Step 2. To a large extent, the picture was executed square by square. However, images that extended over several squares and were easy to continue, for example the slats, were painted at the same time, regardless of the square boundaries. A technical method must be used sensibly, never mechanically. To interrupt work on a form that could be finished without difficulty would only prolong the labor.

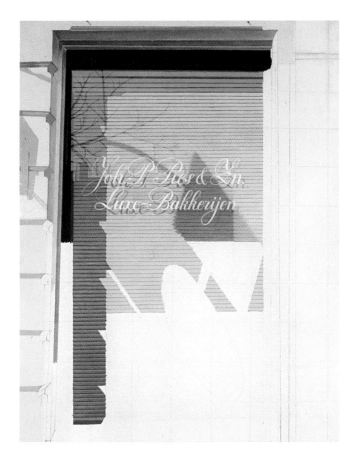

Step 3. The application of paint is not as smooth and devoid of brush strokes as may appear in the predominantly planar color present here. The technique used was to apply a uniform shade of color to an area and then model it according to the shadings in the photograph. This was the case with the light wall strips, the shadow on the left edge of the picture, the upper slats of the blinds that show no shadows. Different painting techniques were used in modeling the different surfaces.

1) Various shadows and shapes were painted over the base color of the window, such as the black ledge frame, the shadow to the right of the stanchions, the tree branches, the lettering, and its shadow on the slats.

2) A second shade was applied here and there on the first color and then both colors were blended together and their boundaries softened; for example, the ochre-colored niches and the dark-green shadow that melts into the light green.

Step 4. The yellow and dark green slats were painted from top to bottom using a somewhat different modeling technique. Each slat consists of a light green upper and dark green lower strip. A dark line separates the individual slats. The light green strip was painted first, then the dark green was partially set into the still damp lighter color. Thus, a clear but soft boundary emerged between the two color shades.

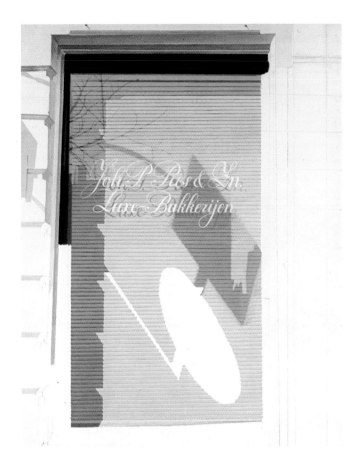

Step 5. Rendering the flowing changes of color on each slot in the round shadow disk presented a special problem. Within each slat, the colors change from dark green to brownish green to light yellow-green, and finally, to light olive green. The transitions within the slats vary, being more compact at the top of the form. There is nothing else to do except patiently paint these color transitions strip by strip (see ''d,'' page 23).

Photorealistic painting is time consuming and tedious. It is certainly not the right method for manufacturing simple photographic enlargements. Through this method, be it ever so exact, the photograph changes its character—totally. It receives a presence and density of color which a photograph, even in this size, can never show. The observer senses that every millimeter of the painting is the result of creative decisions and personal sensitivity to color.

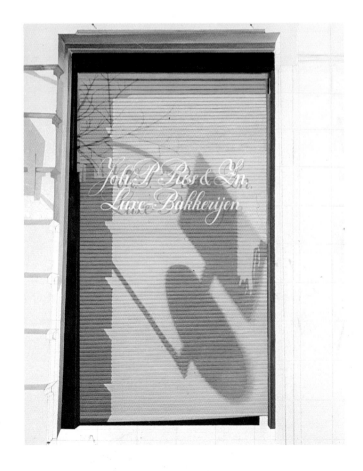

In pictures and drawings which examine photography as a creative art form in its own right, the conventional concepts of "theme" and "motif" take on new meanings. Here the theme of a print from a travel brochure is changed from "life at the beach" to a facination with the technical accident in the multicolor printing which occurred when the monochrome, transparent colorlayers did not register precisely. Because each color separation did not overprint in the same position, the figures appear to have several silhouettes. The images, while still recognizable, are interestingly distorted.

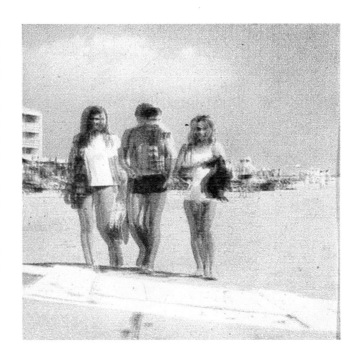

Step 1. Apparently, the artist questioned whether the entire picture from the travel brochure was favorable and suitable for his rendering of this particular technical characteristic of printing. A small section (3 x 3 cm), showing only the three main figures on the yellow sand, and reducing the white object in the foreground to an almost abstract white surface was chosen as this is the section of the photograph where the off-registration is most clear. The building has been left out, and the partially recognizable tangle of people and lounge chairs has become an abstract stratum of the background. From the latently diagonal composition emerges a centrally situated motif.

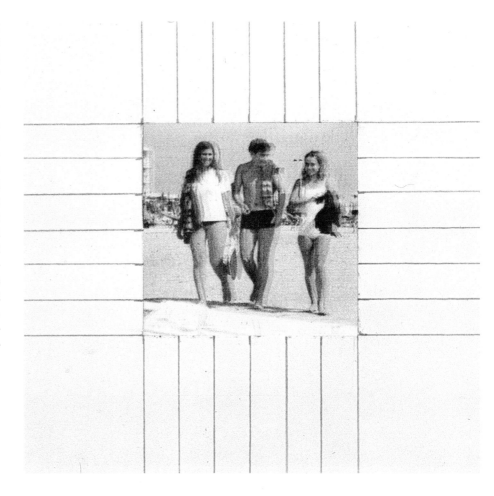

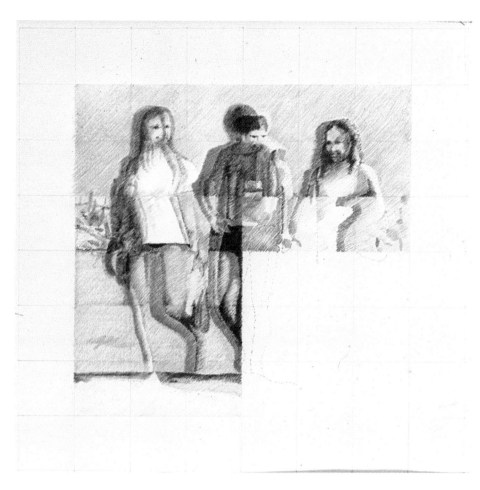

Step 2. What color medium is suitable to reproduce the bright transparent colors which dissolve like colored light? One thinks first of watercolors. But their runny color does not really correspond to the static quality of this crude grid print. For the drawing shown, three common, color-fast pencils were chosen in yellow, red, and blue. Using oblique hatching, the artist was able to capture the grainy texture of the print and to control the density of color through a gradual build-up of lines.

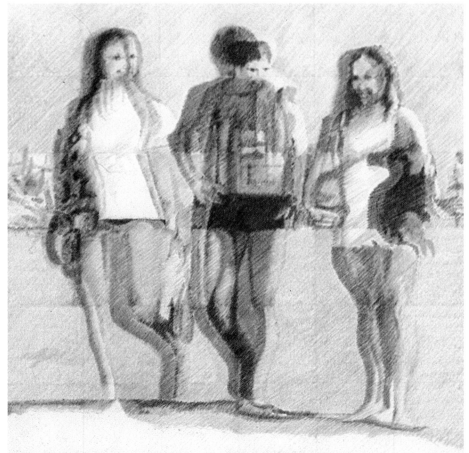

Step 3. The picture was enlarged with the aid of the grid technique. Salient lines were drawn which later disappeared in the hatching. There was no strict progression of the color layers. Colors were often drawn over one another several times, particularly to create the very dark tones. As the print bears no trace of a black plate, black was completely avoided during drawing. A tone similar to black is difficult to make with somewhat hard pencils, and can be done only with great pressure and alternative layers of color (e.g., blue on red, red on blue-red).

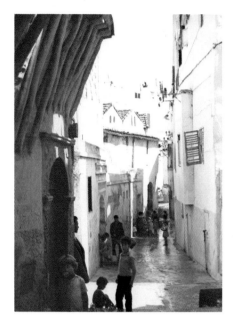 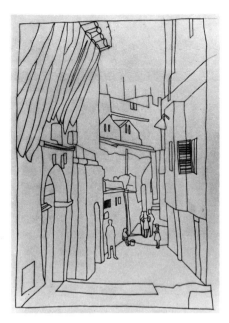

This is a typical problem photograph. The dazzling morning sun glistens on the white houses in the background, while the objects that are already darker—wooden support beams, green shutter, window openings, doorways, people—are in shadow. Such strong contrasts in light and dark result that the film medium can not capture the entire scene accurately. For instance, the overexposed areas in the background are flat and featureless, as opposed to the textures and details apparent in the foreground. Perhaps, the appeal of the photograph is due to this very contradiction. The peculiar clash of colors is noteworthy: brilliant white, a delicate pink, a dab of green, a somber yellowish brown.

Step 1. The colors in this picture are divided into large, clearly defined surfaces. These surfaces are coloristically connected with one another by each having some small patch of one other color: for instance, the small bits of white in the large brown wall in the foreground, the slivers of brown windows in the large white and violet surfaces. The many clear planar forms of the scene encouraged the artist to employ a painting technique which has the same formal principle: the stenciled spray technique. Transparent watercolors, deftly applied, would achieve a similar effect. First, a contour drawing was made, clearly outlining the surface forms. The artist used a pantograph (see page 11), an apparatus which is particularly useful for the enlargement of architectural forms. Some figures in the foreground were left out because they appeared accidentally cropped in the photograph.

Step 2. First a stencil was cut from stiff drawing paper to cover the entire picture except the sky in the upper center. This exposed section was lightly sprayed with bright violet watercolor (very liquified) from a spray gun. A second stencil blocked out both the sky and all the white areas including the borders of the picture. Tiny white spots, which could not be easily cut into the stencil, were covered with pieces of paper that are still to be seen on the illustration. Then the dark violet surfaces were sprayed with their first coat.

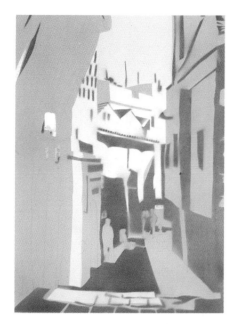 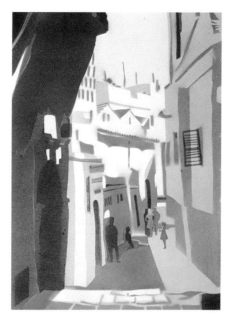 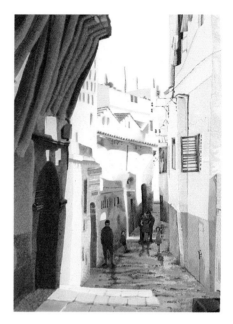

Step 3. A third, still darker violet color was added. As the surfaces are smaller and more disparate, only one area could be sprayed at a time, while the rest of the picture was covered. When the cover paper became saturated with paint, it began to curl up at the edges, despite being weighted down with tiny pieces of lead. As a result, paint crept under the paper cover, in areas such as the staves of the roof and the windows. This accident softened the color boundaries and was advantageous to the sharp light-dark contrast of the composition.

Step 4. Three new color tones have been added: yellowish light brown, middle brown, and black-brown. Each were sprayed over the other in three steps. First the entire surface of the house in the left foreground and some small surfaces in the background were sprayed bright brown. Objects to remain bright brown, and all light areas, were then covered for the middle brown spraying. Finally, the dark black-brown areas were sprayed using individual stencils. At this stage, the work begins to reflect the colorfulness of the photograph in its even, sharply defined surfaces.

Step 5. The entire picture was finally worked over by dabbing with watercolor and opaque white. Surfaces were easily modeled into lighter or darker colors with a dabbing brush. In this way the wood beams received plasticity, the door and window openings depth, the walls, particularly in the shaded areas, a damp, spotty texture, and the street gleams with moisture.

In April, 1980, an article by Margarete Mitscherlich-Nielsen appeared in the German magazine *EMMA* on the relationship between women and their mothers. Ulrike Rosenbach, the well-known feminist artist from Cologne, produced a photomontage for the piece. The photograph shows the artist herself sitting in the lap of a large, painted, female figure from ancient times whose arm reaches across her chest. For the representation of the mother figure, Rosenbach photographed the portrait for the so-called *Mistress of the House,* part of a fresco from the *House of Mysteries* in Pompeii, painted in the 1st century A.D. This collage, made by pasting together pieces of several photographs, is called a photomontage. First the fresco painting was photographed and printed; this print was cut and mounted together with the photograph of Rosenbach; the collage was then photographed as a photomontage, and printed again. The bodies of the figures are intertwined so that they seem to inhabit the same place and time. Both women look contemplative, their body postures are casual. The pose of this photomontage is reminiscent of a popular motif of religious art called a "pietà." The Virgin Mary is shown mourning over the reclining body of Christ. The most famous work of this theme is Michelangelo's *Pietà* in the Vatican which is strikingly similar to Rosenbach's composition. A pietà shows the relationship between mother and son; there is no comparable image for mother and daughter.

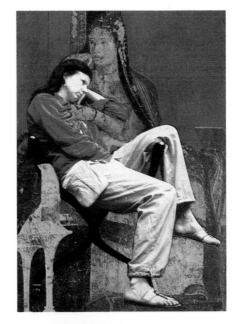

Photomontage (left) and section (6 x 4 cm)

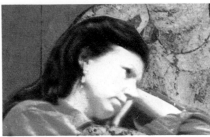
Below: pastel painting (36 x 37 cm)

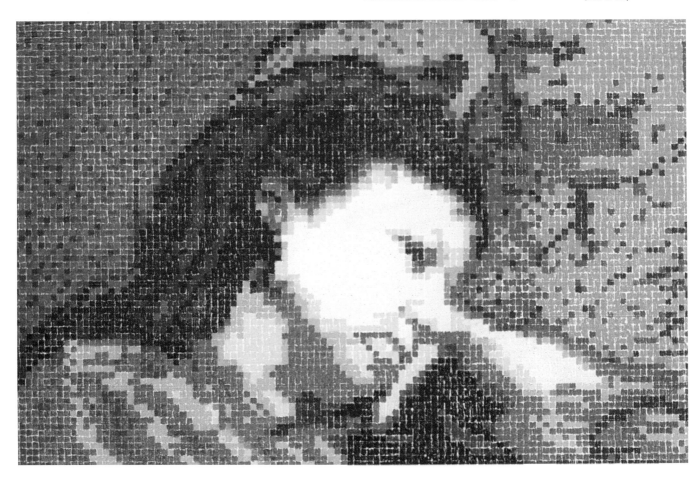

Representations of mothers and grown daughters rarely show their personal relationship. Most often, the theme is general: a comparison between youthful bloom and withered age, innocence and experience. That the theme of mother and daughter has not been considered worthy of representation in the visual arts raises some questions about society itself. Ulrike Rosenbach's composition is a courageous departure from traditional motifs. No less interesting than the problem of content is the artist's sensitive achievement of color unity. First of all, the model is clothed in fabrics that blend with the textures and colors of the fresco—creamy beige, earthy cinnabar. Even her sandals have a classic look to them. Secondly, the repeated photo-graphing and reprinting of the photocollage with the aid of filters, worked to harmonize the color tonality of the various elements (see page 56). The artist chose not to conceal the cut edges of the photocollage as the artificial relationship of the two cut figures reflected her interpretation of the theme. Our illustration shows a pastel painting (36 × 37 cm) from a section (6 × 4 cm) of Ulrike Rosenbach's collage. The color tonality of her photomontage inspired the artist to create a color drawing zeroing in on a section of the larger tableau. In her pastel drawing, Rosenbach emulates the technical characteristics of the screen print in which the forms are broken down into tiny dots to be blended by the eye.

Closeup of pastel painting

Richard Estes is the artist of modern cities, a manmade world of straight, rectangular forms, gaudy colors, strong light reflections, and dark shadows. The main element of Estes' compositions is the mirror images that arise on smooth materials—glass, enamel, chrome, highly polished stone—combined with concrete, architectural elements. For Estes, the reflections are as complete and clear as the architecture. Estes does not copy a single photograph, but combines pieces of several photographs into his compositions. The color application is unusually free for a Photorealist. The brush marks remain clearly visible.

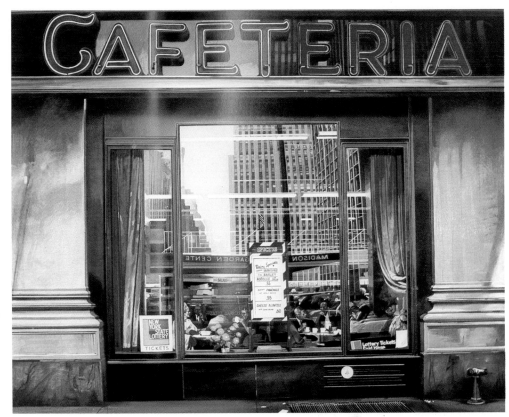

Richard Estes, *Cafeteria*, 1970, oil on canvas, 99.6 × 117.8 cm.

Richard McLean prefers to paint horses and the people who deal with horses. In the late 1960s he began to paint after many years illustrating for horse magazines. McLean uses exaggeration in color and composition to add humor to his pictures. For instance: the sharp light-dark contrasts seen in the reflections in the hide, the folds of the clothing, the green and white leaves—all middle tones seem to have disappeared. On the other hand, the sky is too flat, and the individual blades of grass too precise. Very probably, McLean first created these effects in his photograph by filtering out the gray tones. McLean's work captures the glossiness of the photographic print and eliminates any trace of brushstrokes.

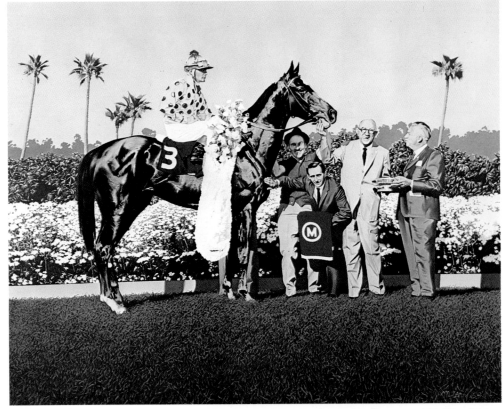

Richard McLean: *Native Dancer in Hollywood Park*, oil on canvas, 1969, 144 × 172.8 cm.

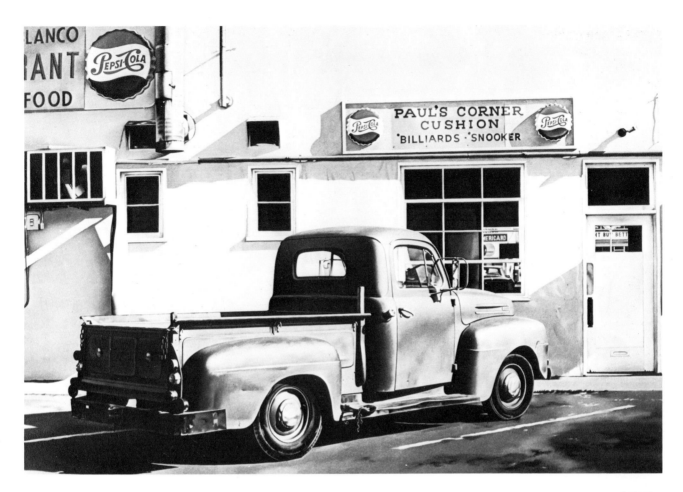

Painting from photographs in the Photorealistic style has not only opened up a new area of artistic perception and execution, but has founded a series of new motifs for painting—scenes, objects, moments in everyday life—which were previously considered unworthy of representation. Everyday objects, manufactured products, landscapes of modern life that are banal, too new to be transfigured by nostalgia, and continually overlooked through daily use, have become topics for artistic interpretation in the aesthetic world of the Photorealists.

Above: Ralph Goings: *Paul's Corner*.
Below: John Hummelhoff: *Sink*, 1972.

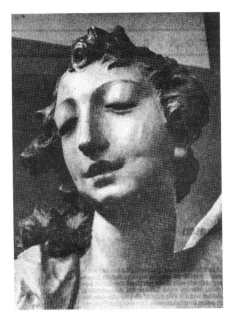

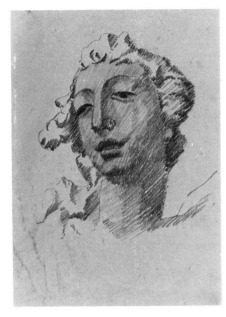

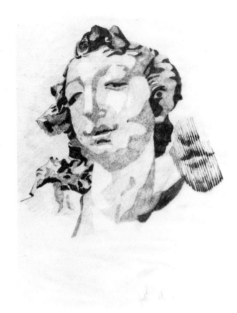

A photograph is altered when reprinted in newsprint. Some image quality is lost, but an interesting esthetic may be found. Newspaper printing shows the screening clearly, resulting in a picture which is less realistic than a grainless photograph. When the screen, as in newspaper printing, is clearly recognizable to the naked eye, an interesting contrast arises between the graphic texture of thousands of dots and the plastic forms of the underlying picture.

Variation 1. Pencil drawing. The artist has decided to emulate this contrast between texture and form. In this variation hatching lines replace the screened dots. The artist creates tones, volume, shading by altering the number and density of short pencil strokes. Although almost all the strokes are the same length and move in the same direction, a plastic form is created.

Variation 2. Pencil drawing. The hatched drawing of Variation 1 suggested the idea of reducing the medium gray tones in a second drawing. The effect of dropping out the middle tones clearly flattened the form and makes the image look less natural. One can learn much about drawing technique through a series of drawings such as these. It is possible to make a tracing of the print or photograph in order to concentrate on the execution of volume and plasticity through lines—their direction, rhythm, darkness, density, and weight.

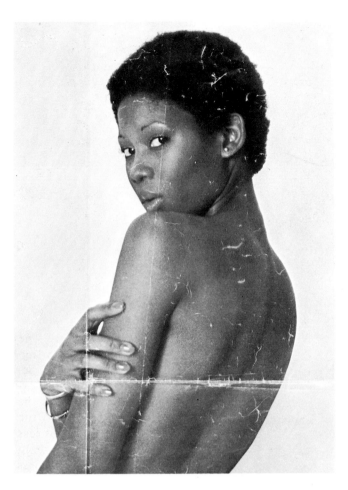

Portrait drawing from photographs is no longer a secret. Today, practically every small city has an artist who offers this service. It is certainly more comfortable for the customer than posing for hours, and it offers the artist a certain security and possibility of control. The artificiality of this method should raise no question—think of the excellent portraits by Manet, Degas, Gauguin, Matisse, Cézanne, Picasso (see page 7), up to the Photorealist Chuck Close. Anyone who can paint will not be ruined by the photographic mode, whether freely transforming the photograph, or interpreting it in Photorealistic style. Conversely, a photograph will not make an artist of a dabbler. Andy Warhol, the contemporary American artist, created whole series of pictures reproducing photographs of movie stars and famous personalities into sieve prints in wildly imaginative colors. To Warhol, the person was of less interest than the image that business, advertising, and public taste had created. Portraits from photographs is a highly topical theme of our time.

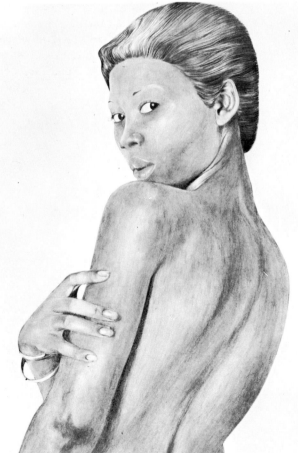

Pencil Drawing by Remo Copparini. For example, movie star posters, publicity shots, and pin-up photos found in magazines are so pervasive, our image of these people is heavily influenced whether we want it to be or not. In the drawing shown here, the artist wanted to achieve the greatest possible exactness, but the model is rather severely altered in spite of this. The velvety, insinuating character of the photograph is partially lost. The sweetness of the face has become harsher, and the soft, natural hair looks stiff and wiglike. Using the wiping technique with pencil has created a different texture and tonality in the skin than that seen in the photograph.

Good culinary photographs have a strong, sensuous appeal, arousing the senses of smell, taste, and touch. In fact, magazines devoted to culinary arts sell very well. In this photograph from the German magazine *Essen und Trinken,* the textures of the different materials create an intriguing environment for the soft round fruits: the clear glass with shining droplets of juice reflecting light, pearls of foam, the cloudy liquid which partly veils the circular fruits and softens their edges. The plasticity of the individual fruit is sometimes lost in darkness, but the whole gastronomic treat is gathered together into one bold shape determined by the container.

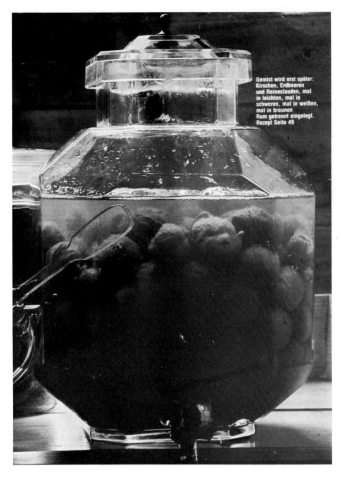

Pencil Drawing by Stephanie Kapp. The artist is presented with the difficult, formal problem of rendering an inner and outer plasticity. To do this she dramatizes the material contrasts between the upper and lower part of the glass tureen. The glittering and drop-bedecked glass on top is drawn with short, lively hatchings, interrupted by several small white spots inside shadows. In contrast, she depicts the cloudy liquid with an even plane of long, polished hatch lines. The fruit, as well, is molded by hatchings which change direction only slightly from the lines of the liquid. Expressed graphically, the liquid washes around the fruit. The plasticity and volume of the individual forms is somewhat suppressed, and the light and dark contrasts have been muted. Some differentiation has been maintained: the fruit above is lighter with darker shadows, while the fruit below appears evenly shaded. The rendering of the interior forms has helped indicate the plasticity of the container.

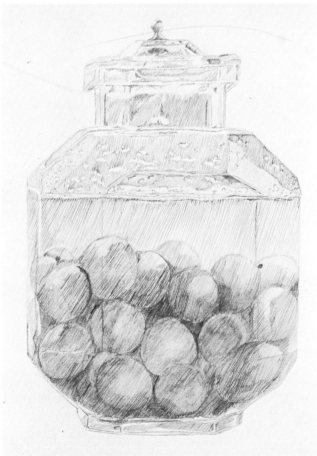

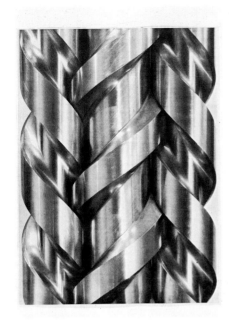

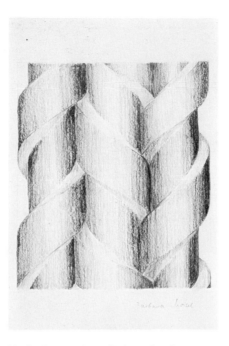

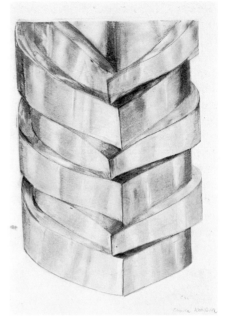

It may seem contradictory to want to study plasticity, volume, and texture from a photograph. But the challenge in drawing is to make three-dimensional plasticity visible on a two-dimensional surface. Photographs can be extremely useful for studying this problem.

Variation 1. Pencil drawing by Barbara Moisel. The artist was concerned with rendering the complicated plasticity of the object and the interlocking positive and negative spirals. After some preliminary studies, she drew this variation completely from memory. One recognizes that the artist has reversed the direction of the spirals, but the drawing does not suffer from this change. To mold the rounded, swelling bands, she used soft, vertical pencil strokes that practically flow into one another. Because the object is composed of a series of identical forms, it was essential that these forms be modeled in a uniform, repetitive manner. All the vertical curves become darker as they recede, while the diagonal grooves become lighter with depth. This contrast of dark and light areas produces the shape and plasticity of the object.

Variation 2. Pencil drawing by Ursula Wohlfahrt. This drawing has a completely different character. The rendering of plasticity is less successful because the edges and seams are too sharp and linear. The artist is more concerned with the shiny polished metal surface. She has diminished the strength of the vertically running highlights, sacrificing some clarity and technical exactness.

A young, open beech forest on a flat, rolling hill, the ground covered with snow, the sky white with snow. On the horizon, a thickening gathering of slender tree trunks. The forest floor and the sky are flat as a piece of paper. The spatial effect of distance is created by the trees: their size, breadth, darkness, positions, and shadows, cast in horizontal bands across the snow surface. The trees and branches, dark as they are, do not stand out in sharp contrast to the snow-white landscape. Fallen snow clings to the tree trunks, softening their edges, accenting the sweep of the trunk near the ground and the gentle bend of each vertical line. The snow cover modifies contrasting elements, unifies and abstracts the scene. What appears to be a simple scene to photograph, draw, or paint, is actually filled with tensions and subtle interrelationships.

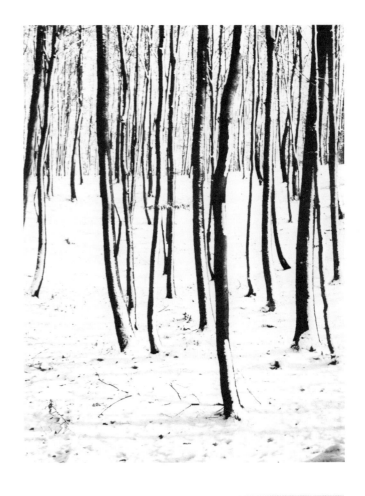

Step 1. The drawing is to be done in charcoal. Charcoal provides a scale of tone from complete black to light silver-gray, and a range of texture from the prominently drawn line to the ethereal, blurred surface. These characteristics of the drawing material agree with the forms and coloristic elements of the photograph. The soaring lines of the tree trunk are vigorously drawn, specifically their left contours, which are darkest in the photograph. Thus, the canvas is rhythmically divided, but the rise of the hill and the distant sky are not yet recognizable.

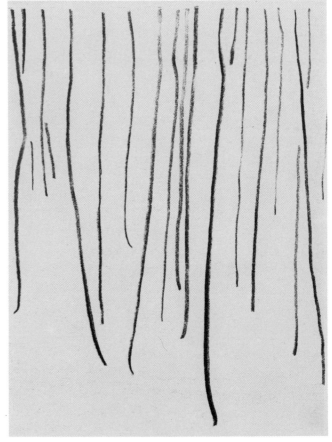

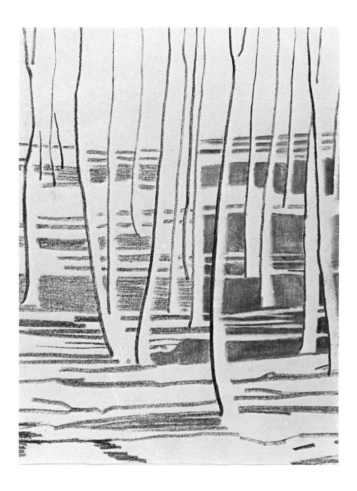

Step 2. The artist creates shadows. Carefully placed horizontal lines are drawn across the picture, and then rubbed with the finger or a paper stick to an even consistency on the right half of the picture. The ground is molded by the shadows, and the thickness of the trunks has become visible. It is still not clear that the ground is rising, or that the horizon line is the high point of a hill.

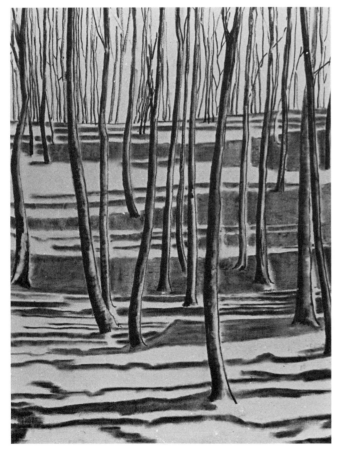

Step 3. Many small lines indicating trees at a distance, are drawn into the background to give the space the sense of depth, while closing the depth at the same time. The impression of a hill is created. The trees are completed. The right contour lines are drawn, thinner and lighter than the left. The charcoal dust between the contours is rubbed, giving the effect of roundness and volume to the tree trunks. Charcoal is added in spots, and removed with a kneadable eraser in others. The drawing has a somewhat different accent than the photograph. The artist's interpretation is concerned with the contrast between strong verticals and horizontals and the working of a sinuous plasticity over a flat surface.

Reflections and movements, always in flux, always changing, are as fascinating to observe as they are difficult to render. At the beginning of the 20th century, the Futurist school focused on the presentation of movement in art. Due to the discoveries made by inventors in this century, the phenomena of speed began to determine the life of mankind. The photograph presented here shows cyclists in motion, each at a different distance and angle to the camera. It is interesting to observe how the blur in the foreground and right side gradually increases.

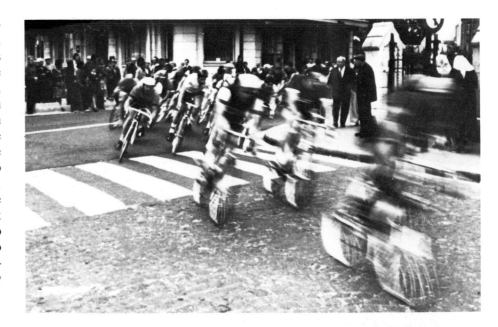

Variation 1. There is no attempt to make an enlarged copy of the photograph in this drawing. The drawn strokes, vertically executed hatching, remain clearly visible. All the forms, and the richly shaded chiaroscuro, are reproduced with this hatching. Contours were consciously eliminated to maintain the sense of continuous movement and action. The dark-to-light transitions are graduated by varying the hatched lines. The artist's main interest is the dynamic relationship between the moving bodies and the surrounding space. The first part of the drawing was completed using the grid technique (page 9). Movement has been transformed into planar forms, modulating in light and dark.

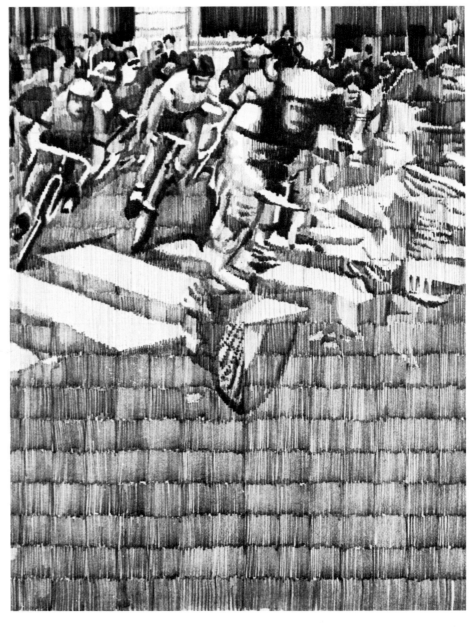

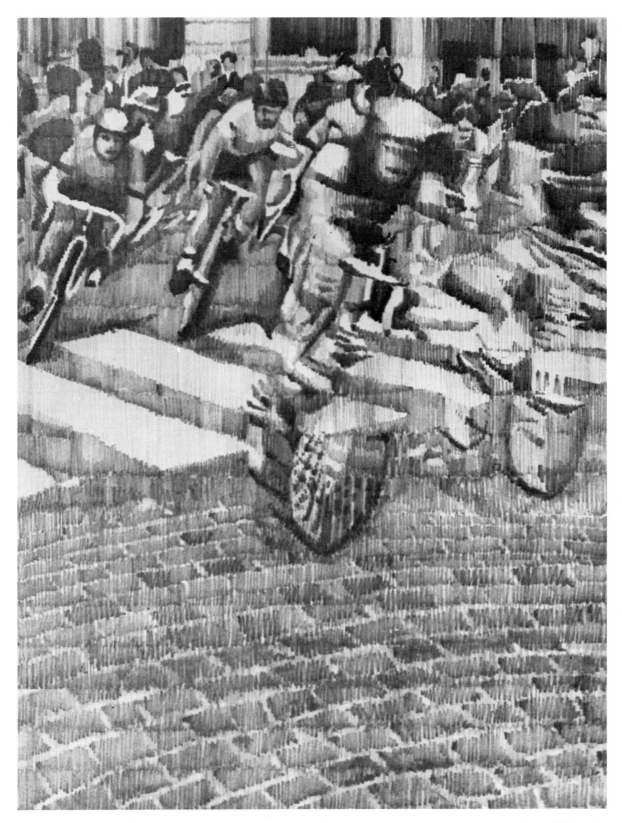

Variation 2. The drawing was executed a second time, following long observation and familiarization. This time, forms were clarified, surface boundaries corrected, and the strongest dark accents were selected. The structure of the street pavement was drawn over the rigid and unspatial structure of the grid pattern adding depth to the strong verticality, and providing the riders with the necessary space in which to move.

While still rendering in short hatched lines, the artist has now achieved the illusion of momentum, action, and space which created the excitement in the original photograph.

The fortresslike mansions and municipal buildings of Florence date back to the early Renaissancè when their dual role was to provide protection against attack as well as a home. The formidable doors and gates complementing this architecture, are handmade masterpieces wrought in strong relief. Their massive wood planks with deep grooves and crevices, shaped metal nails and bands, cast iron knockers and knobs are all very stern and severe, almost clumsy. The bright southern light turns these reliefs into threatening traps. The shadows cast from knobs and knockers in profile become forbidding apparitions, the nailheads turn into lancepoints, and the deep shadows of the wooden framework pose an impenetrable barrier. One might wish to go beyond the photograph and paint a picture contrasting the uncommonly rich character of the wood with the play of light and shadow on the repetitive metal decorations. The attention of the observer would be directed to the material itself, rather than the unspoken feeling of anxiety and menace which the photograph provokes.

Step 1. This geometric and rectilinear image is easy to enlarge by measurement with a ruler or paper strips.

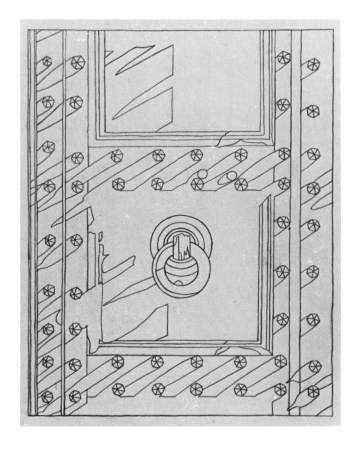

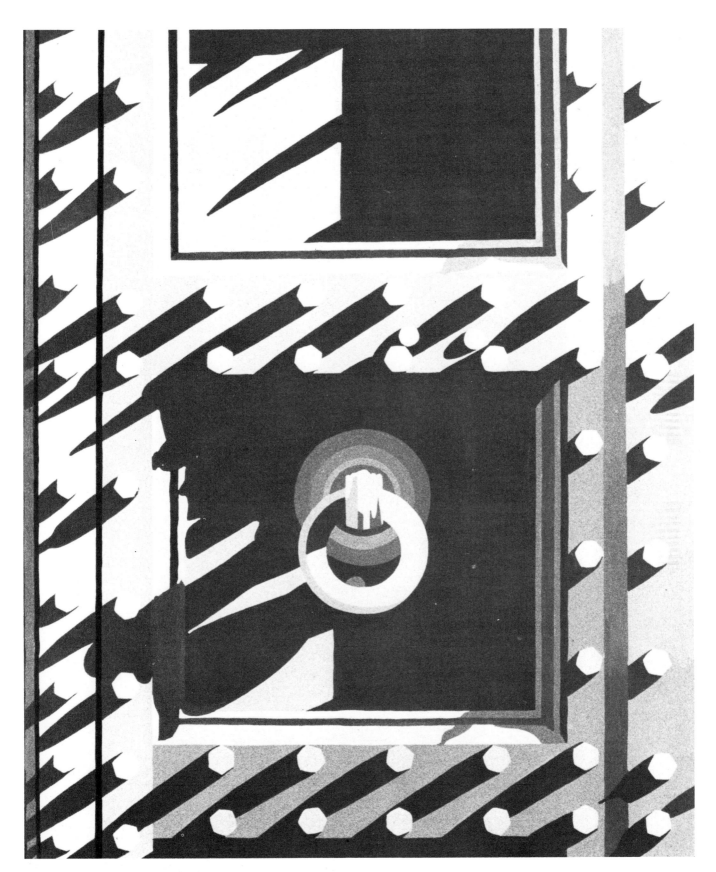

Step 2. The artist has limited his palette to black, white, and a rich variety of gray tones in tempera color. This type of painting in gray tones is called *grisaille*. Here, areas have been filled in with uniformly applied gray tones of medium darkness, neither so bright as the brightest, nor so dark as the darkest portions of the corresponding areas in the photograph.

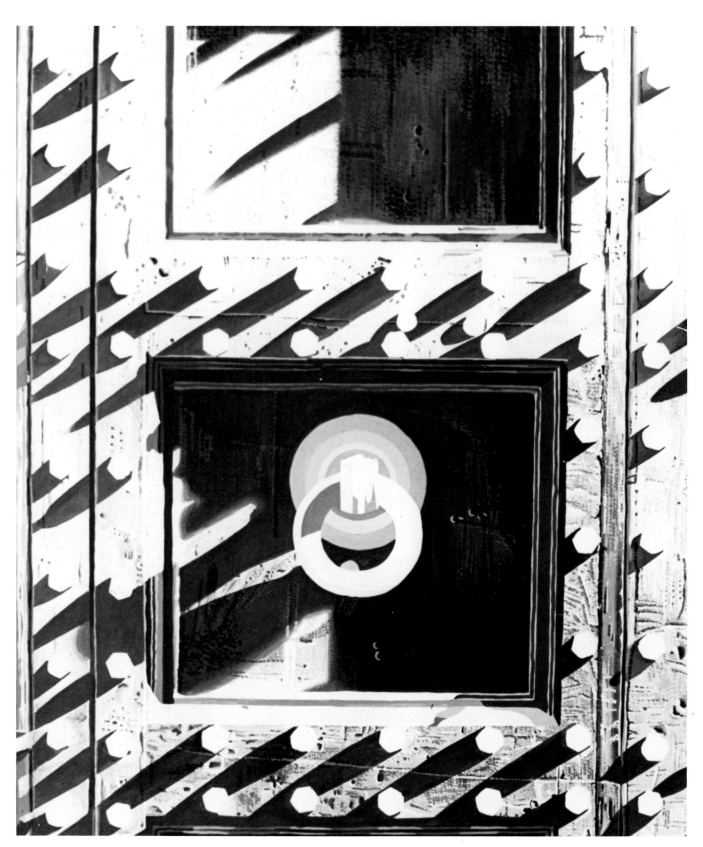

Step 3. This step consisted of protracted labor. The lighted and shaded surfaces—holes, grooves, wood grain, nicks, and notches—must all be elaborated more clearly than they are in the photograph. This is particularly true for the shadow areas that are simply black in the photograph. The artist has attempted to render the continuous texture of the wood, which is lost in the photograph. Where the photograph offered no reference points, imagination completed the work.

Step 4. Finally, the nails and the cast iron ring are detailed. The right half of the nail surfaces belong to the brightest areas in the picture. They slowly modulate into the darkest surfaces—their shadows. This image is repeated fifty-four times and distributed at regular intervals over the entire canvas creating a textured pattern which engages the eye and unifies the composition.

The grid reduces the picture, in this case a part of a newspaper photograph, into points that are arranged with strict geometry on a square base. The centers of the screen dots lie exactly where they intersect the lines of the square grid. This grid does not proceed horizontally-vertically as in the illustration below; it is turned at 45 degrees. (In multicolor printing where different screens are printed over one another, the screens are individually turned at 30 degree angles to each other.) The screen of the small sea and island landscape is very coarse: 20 × 20 dots per square centimeter. The large wave moving over the entire breadth of the picture gains a static quality; it looks almost like a mountain. But the irregular fringe of the wave crests maintains the impression of movement.

Watercolor Drawing. The number of grid points in relation to the motif is the same as on the print. For the drawing, the print is enlarged and the point size, reduced to five, is set up on a vertical-horizontal grid. The enlargement naturally does not come to full realization here as the picture has been reduced for this book. The reduction of the point size to five strengthens the light-dark contrasts; the large forms (cliffs, waves) almost threaten to separate from one another. The alignment of the grid coincides with the principal alignments of the motif (horizontal waves, vertically rising cliffs). These large forms solidify the composition and counteract the dissolution into dots.

Today, photocopy machines are found in offices, libraries, photography, and stationery stores. Writing and linear drawings usually reproduce well through photocopying, as the changes which occur are seldom conspicuous in writing and linear motifs. Photocopying more complex pictures is different, and, in the case of photographs, the difference is particularly great. The many nuances of light and dark in color or black-and-white photographs are reduced to a few shades of gray. This often produces astounding and attractive effects reminiscent of drawings with thin watercolors, granular chalk drawings, or aquatint techniques. As a result of photocopying, the imagery is flattened, confusing details become condensed and simplified, contrasts in light and dark values become bolder, while patterns with little contrast often appear faint. Our illustrations show the possibility of making a picture using a small portion of a photocopy. The simplified character of the photocopy and its fuzzy texture are captured in the powdery strokes which soft chalk makes on raw paper.

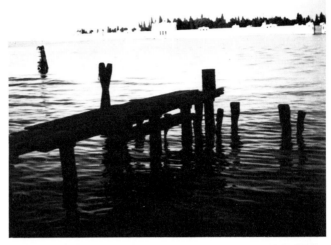

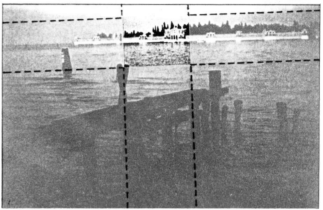

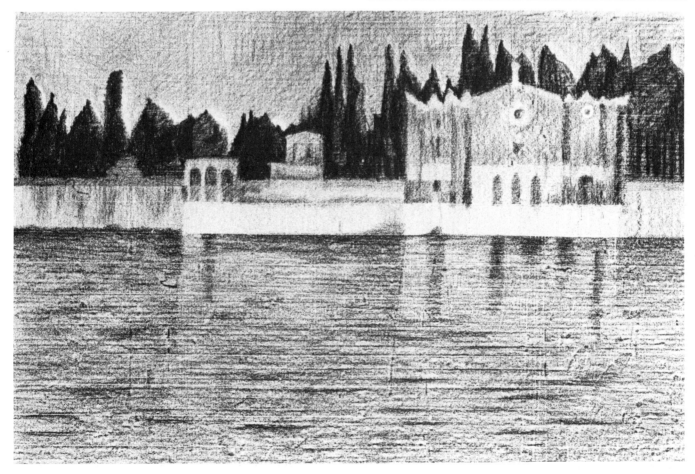

Even the most intense examination of a photograph cannot replace the observation of nature. But a living flower and its photographic image are fundamentally two different things. The photograph by H. S. Dommasch shows an artificial, paper poppy flower. The petals are of such sheer delicacy, they would hang formlessly, were they not folded a thousand times. The restless up-and-down of light and dark surfaces, the contrast of illuminated and partially shaded areas, the deep dark patches on the ground, the plastic stem and stamens, all served to entice the photographer.

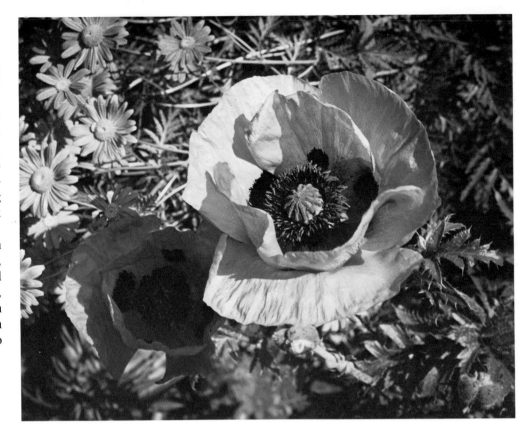

Drawing. In the drawing all these elements are rendered in line. An XXB pencil is used to produce delicate grays as well as the brilliant blacks. Light-dark variations are created through variable darkness, breadth of line, and spacing between lines. All lines extend, radially, from the center of the image. This strengthens the impression of inner dynamism, which is felt more intensely in the drawing than in the original photograph.

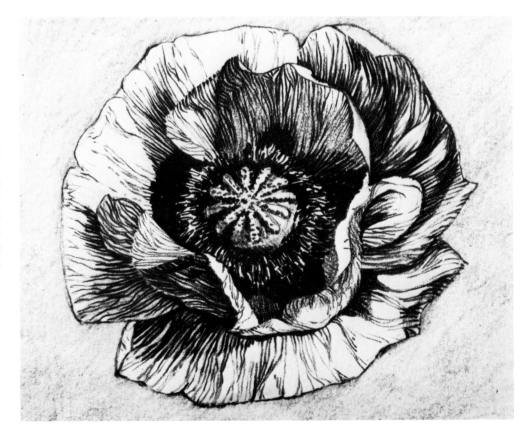